DO NOT BLOCK GATE

DO NOT BLOCK GATE

THE 2024 BARKLEY MARATHONS

DAVID MILLER

Vertebrate Publishing, Sheffield
www.adventurebooks.com

FOREWORD

For nearly forty years, the Barkley Marathons has taken place in a remote corner of East Tennessee. On the surface, it's an arbitrary test designed by an enigmatic race director who goes by the pseudonym of Lazarus Lake. Runners have sixty hours to navigate over 100 miles of dense briar-covered forest while climbing the equivalent of Everest twice.

It appears that it's designed for people to fail. And about ninety-nine per cent of attempts do fall short of the full distance. But through that lies its true purpose: to provide an opportunity for all participants to push beyond their perceived limits and for a small number to achieve the kind of success that only exists when failure is likely.

It took nearly a decade for Mark Williams to become the first finisher of the full 100-plus-miles distance, and in the quarter century that followed fourteen more joined him. I grew up right next to the Barkley course, on farmland where my family has worked for over two centuries. I've now had the good fortune of being involved in the race in some form since 2015. In that time, I've seen both incredible triumphs and agonising defeats.

I've experienced the agony and ecstasy of my own first finish in 2017, pushing my body beyond what I thought was possible while most parts of my mind had abandoned me. I've seen years with no finishers, experiencing defeat myself multiple times. In my second finish I had the joy of leisurely watching a beautiful sunset while I looked down from the mountain that I had looked up at through my childhood bedroom window.

I sat right in front of the heartbreaking scene of Gary Robbins coming up just short. In 2023 that story was reversed, with Karel Sabbe of Belgium finishing with only six minutes to spare. He followed Aurélien Sanchez of France, the two of them becoming the only non-Americans to finish since Mark Williams of the UK in 1995.

But I don't know if there will ever be another year to match 2024. Ihor Verys was the first finisher for both Canada and Ukraine. I tied with Jared Campbell for the most finishes at three before he came in for his fourth shortly after, the two of us accounting for over a quarter of all Barkley finishes. Greig Hamilton then became the first finisher from New Zealand while also making 2024 the first year with more than three finishers.

But still, no women had ever finished Barkley. Jasmin Paris had all the right ingredients to prove that it could be done, but with time ticking away seemingly everyone had conceded she wouldn't make it on her third attempt. The only person whose opinion mattered, Jasmin herself, had not conceded anything. She pushed alone down the last long descent and over a stretch of painfully runnable terrain before she arrived within sight of camp.

In yet another first, Carl Laniak waited at the gate as the effective race director. But Laz was there as well, delighted to see what he had spent so many years saying couldn't be done. Edwin 'Frozen Ed' Furtaw, the first finisher back in 1988 when the race was 'only' three loops instead of five, stood with his trademark beaming smile. With just one minute and thirty-nine seconds remaining until the sixty-hour cut-off, and absolutely nothing left other than her relentless focus and determination, Jasmin became the first woman to finish the Barkley Marathons.

In that moment, seemingly the most unexpected and pivotal incident in the history of an event known for its unpredictable changes, what became clear is that this is the constant it was meant to be all along. The new was built upon the old, all of us pushing our individual and collective limits, bricks in a tower that now reaches to previously unimaginable heights. The race itself will continue to evolve and become more difficult, forcing us to grow further. Who knows what will be built upon this latest brick – who will be inspired to pursue their passion and take on challenges that they otherwise might not have thought possible.

David Miller was there to capture that moment. His photos aren't just of people, or of a place, but of moments in time that pull those unique ingredients together in just the right way to share the experiences of a few with many. Key to that is that the photos capture the moment without affecting it. Barkley will never be a mass participation or spectator-friendly event. For decades it was barely known, and most people involved in the race, including me, would personally be content or even prefer for it to stay that way. But the stories, the messages and the experiences from the race should be shared. Daughters everywhere should be inspired by Jasmin's achievement, just as mine were watching her finish. Thank you, David, for helping make that possible.

John Kelly

INTRODUCTION

I had a vision for the 2024 Barkley Marathons and that was to create a black and white photojournalism book documenting what is arguably the most mythical and hardest footrace on the planet.

Time moves differently in Frozen Head – it's like you're somewhere else away from the rest of the world. The Barkley is special; it's hard to put into words just how unique the whole experience is. When you arrive, you're welcomed as part of the Barkley family; it doesn't matter if you're a runner, crew or media, you're just part of it.

I first picked up a camera during lockdown in 2020 as a distraction from the global pandemic. The subsequent journey leading up to the publication of this book was unexpected but something I wouldn't ever change. I didn't realise I was a creative until I was 34, but when I have a camera in my hand it just feels like an extension of myself. My photography is there to be interpreted and my style is something I've carefully crafted over a short space of time, mainly by taking influence from the ultra and trail running community.

Armed with a Leica Q2 Monochrom my trip to Tennessee had purpose. I first held this camera in the Leica shop in Mayfair, London, late in 2023 and it was during that moment I knew this camera was going to do the work at the Barkley. I wanted to try something new and showcase the Barkley Marathons through a particular photo-journalism style. No hiding, just raw, unfiltered and true documentation. Only one of the photos in this book has been edited (to disguise a map); the rest are unedited. As they're straight off the camera, this adds to the effect and gives the viewer undisturbed imagery of what really went down in Frozen Head.

Little did I know that 2024 would likely prove to be the most iconic year in Barkley Marathons history. Seeing five finishers for the first time and Jasmin Paris becoming the first ever female finisher was nothing short of breathtaking. I won't ever forget that moment – I remember cheering behind the camera witnessing Jasmin touch the iconic gate with one minute and thirty-nine seconds to spare before the sixty-hour cut-off. I couldn't believe what I had just witnessed and, quite honestly, I don't believe I'll ever capture a moment this important ever again. I firmly believe this.

Thanks to those who backed this Kickstarter project because without you this book wouldn't be a thing. I feel so privileged to help immortalise the 2024 Barkley Marathons.

David x

ACKNOWLEDGEMENTS

I'd like to thank everyone who has helped with the production of this book. Thanks to my family and friends who have supported me and encouraged me to pursue my passion and follow my dreams. The ultra and trail running community for continuing to inspire and encourage me to keep this up when I haven't always wanted to. Vertebrate Publishing for sharing this vision. Lazarus Lake for giving me the gift of photographing the Barkley. Photographers Alexis Berg and Howie Stern for showing me the ropes during Barkley 2023. Jacob Zocherman, a friend for life. Jasmin Paris, thanks for finishing and making this book even more special. Allie Bailey for being Allie. The South Coast Sharks. Anna Wiles, thanks for believing in me. Tom Carter for being my best mate. My boys, Louie and Freddie, for allowing me to do this and allowing me to teach them to chase their dreams.

DO NOT BLOCK GATE

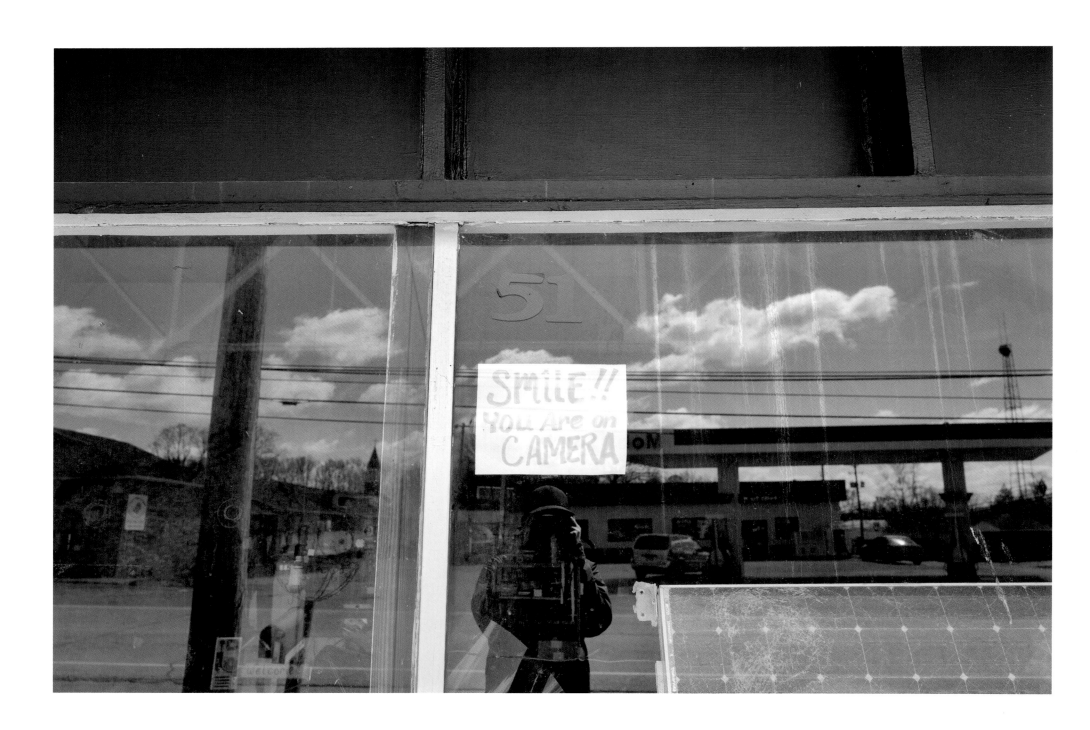

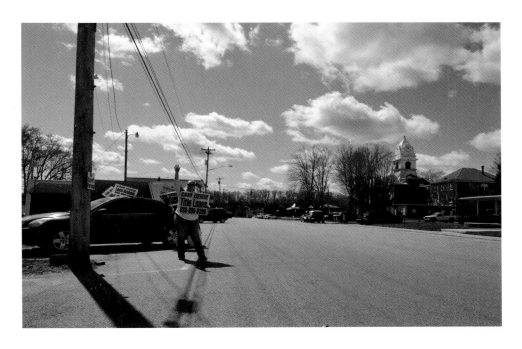
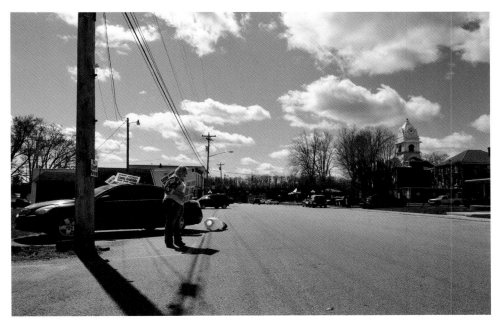
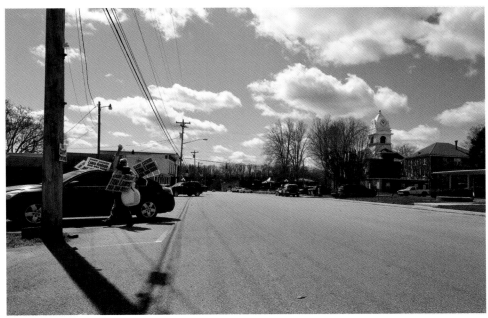

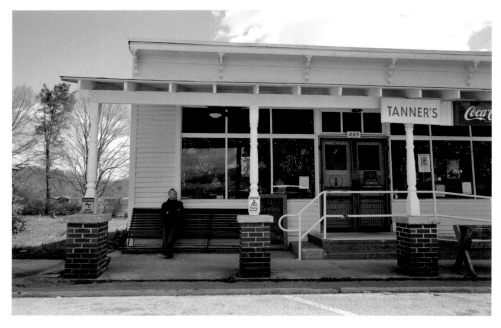

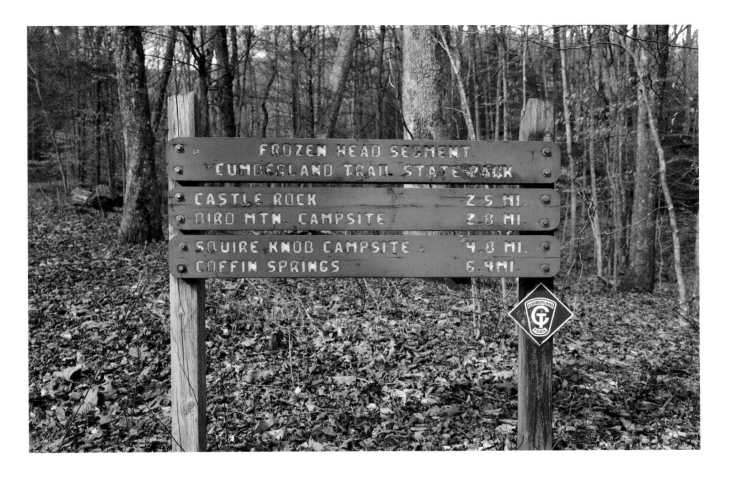

FROZEN HEAD SEGMENT
CUMBERLAND TRAIL STATE PARK

CASTLE ROCK	2.5 MI.
BIRD MTN. CAMPSITE	2.8 MI.
SQUIRE KNOB CAMPSITE	4.8 MI.
COFFIN SPRINGS	6.4 MI.

STAY ON TRAIL

BIG COVE BRANCH

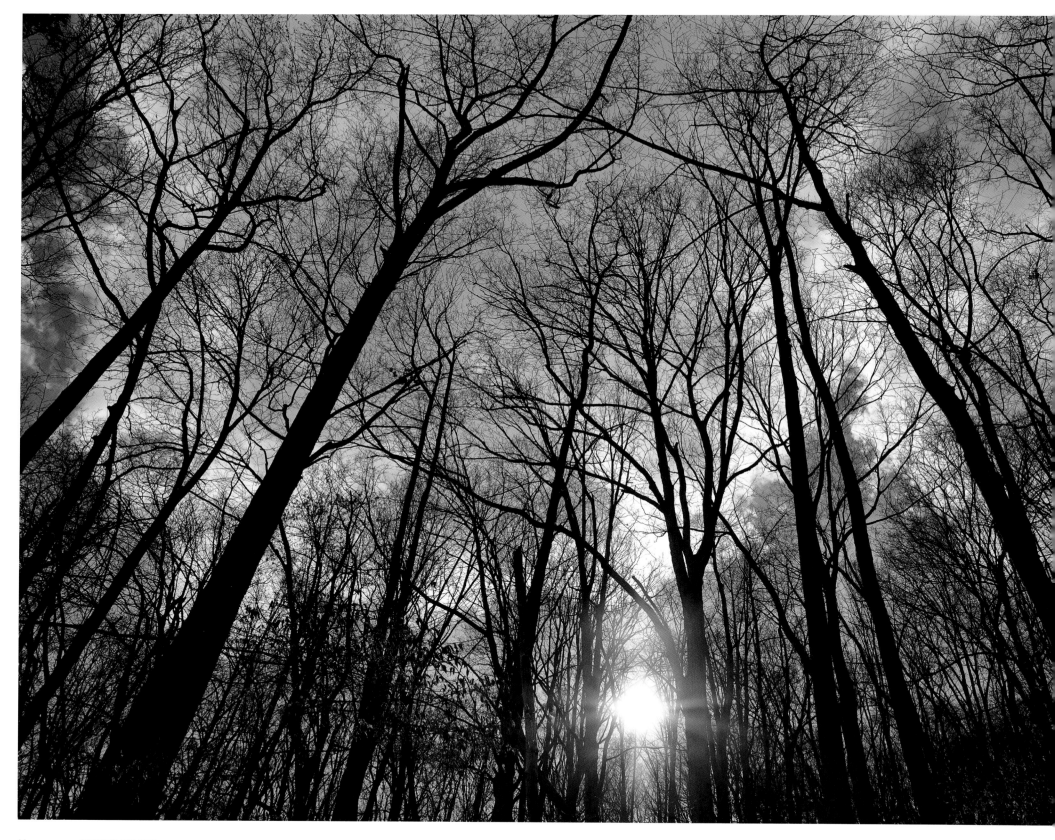

DO NOT BLOCK GATE

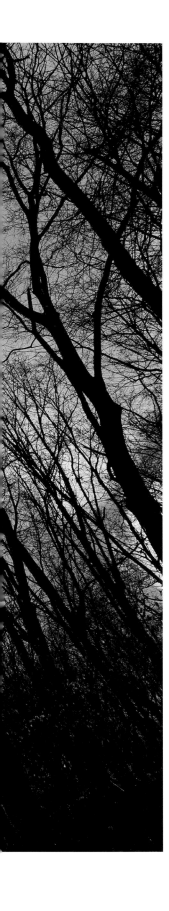

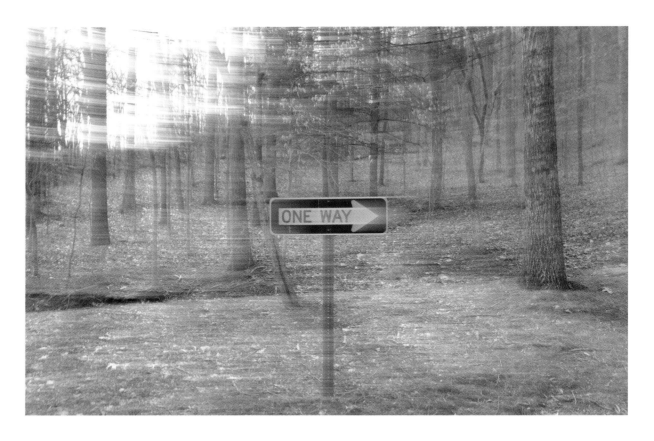

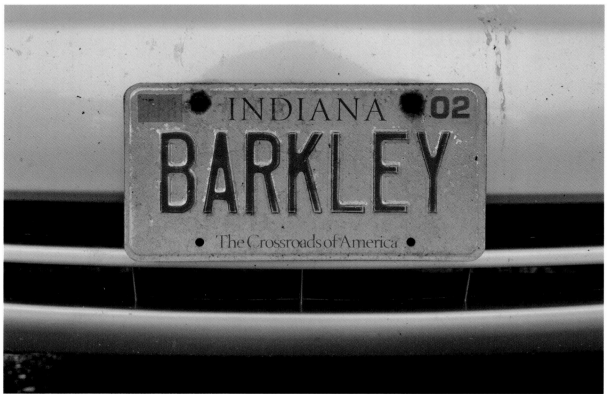

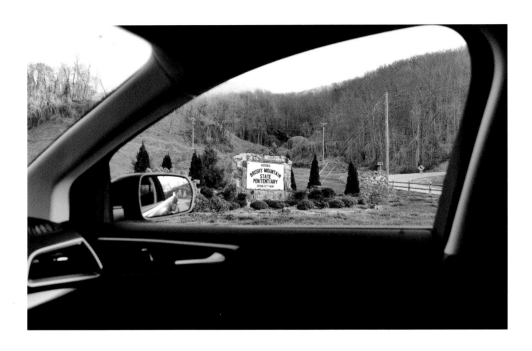

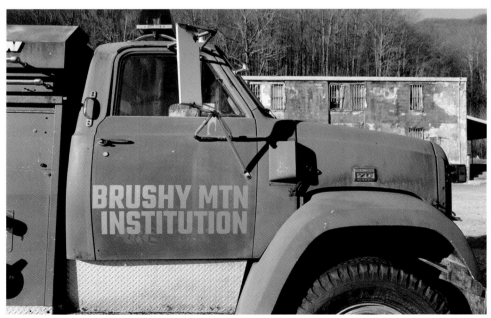

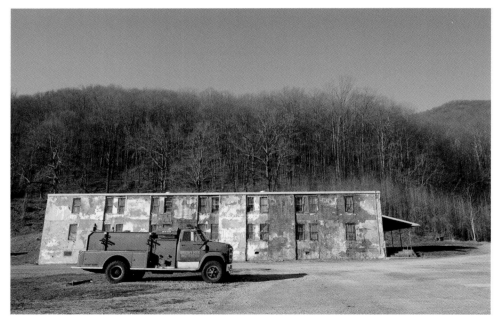

DO NOT BLOCK GATE

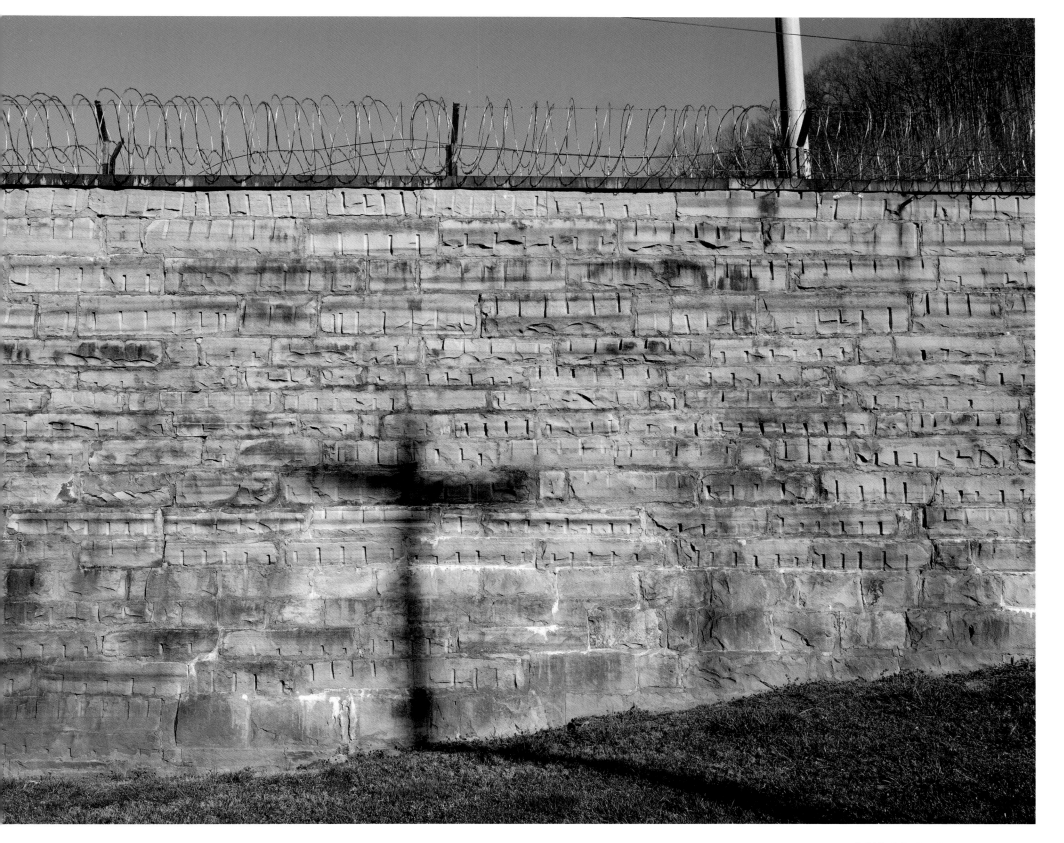

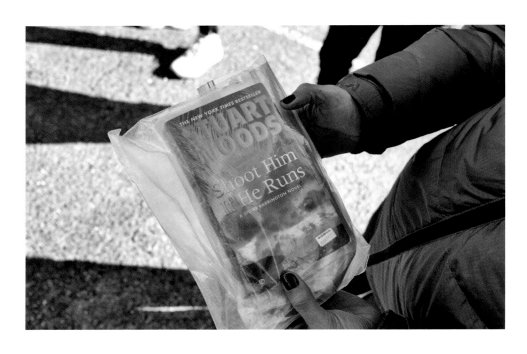

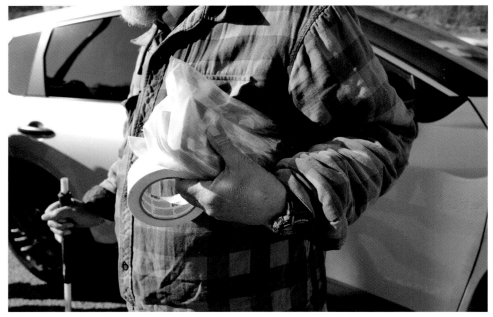

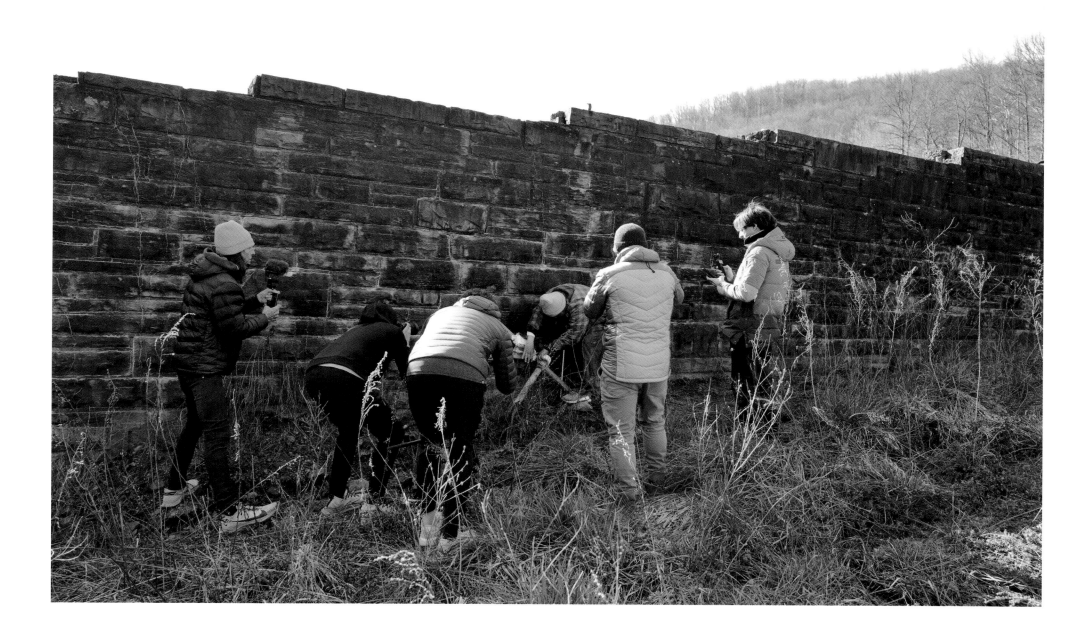

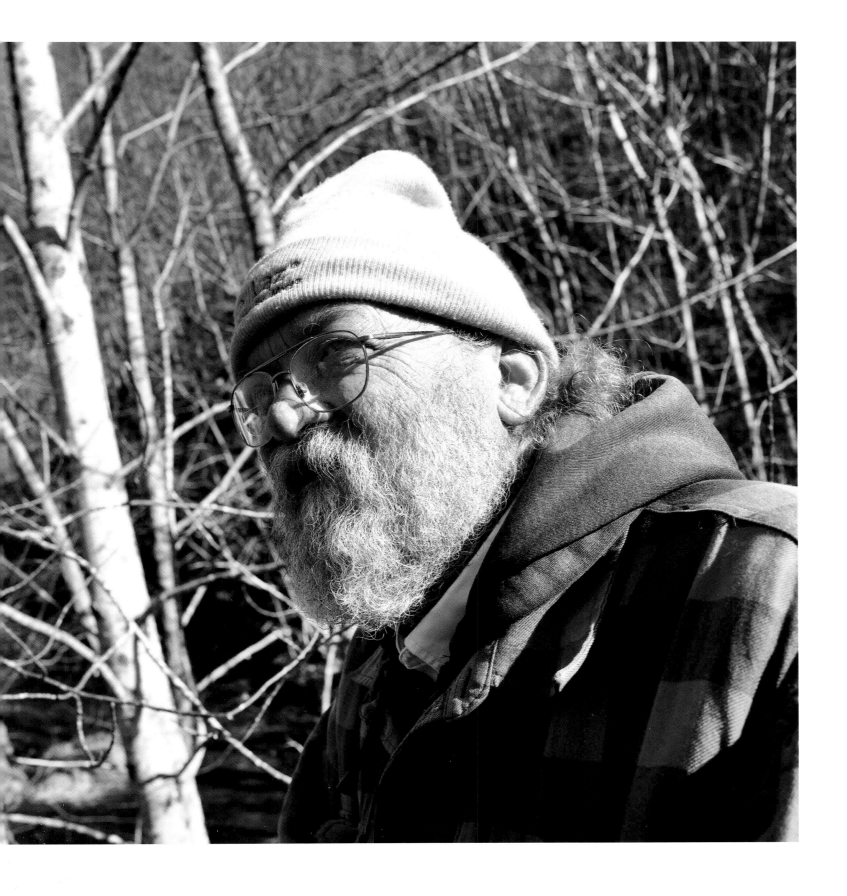

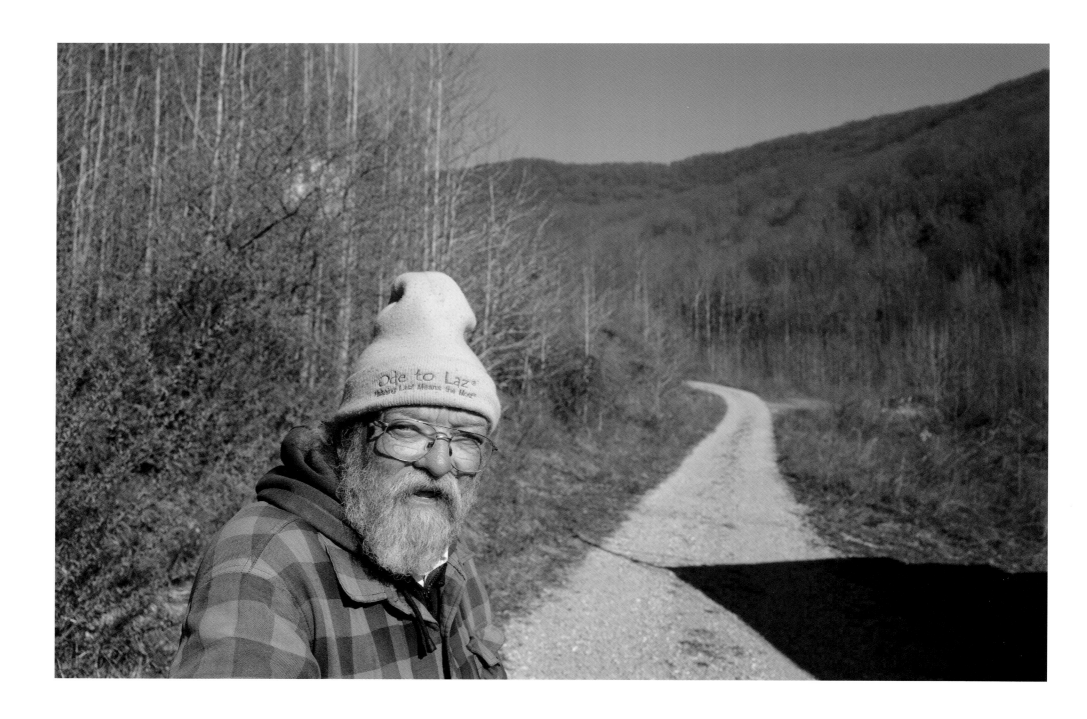

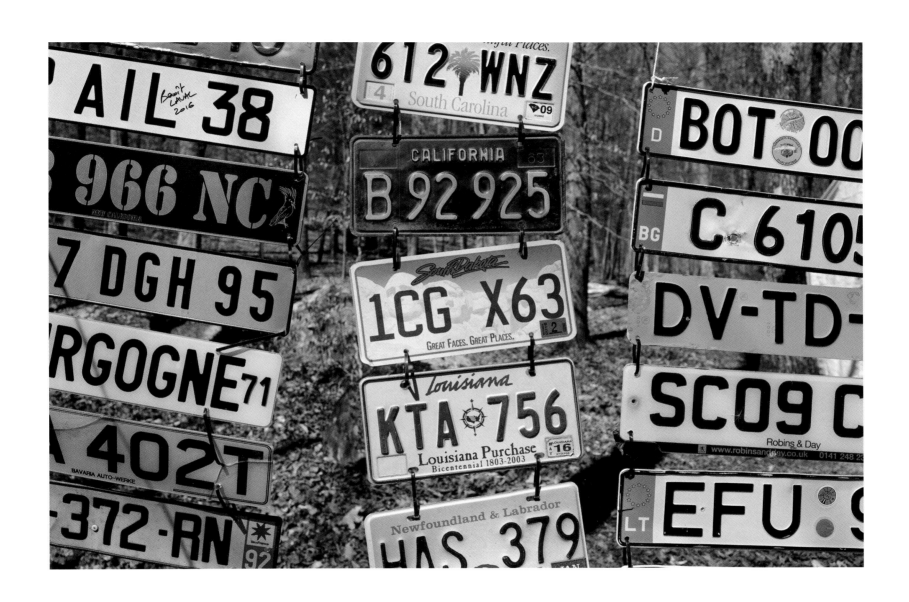

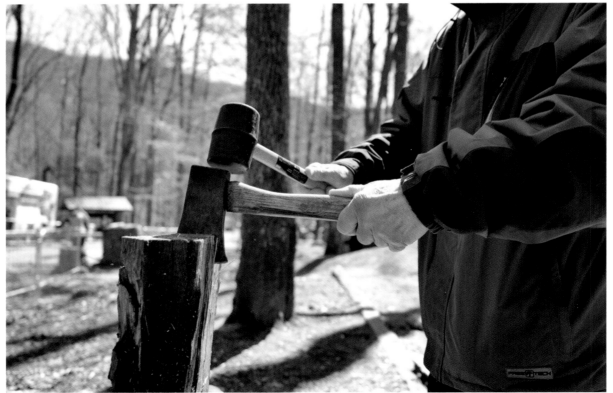

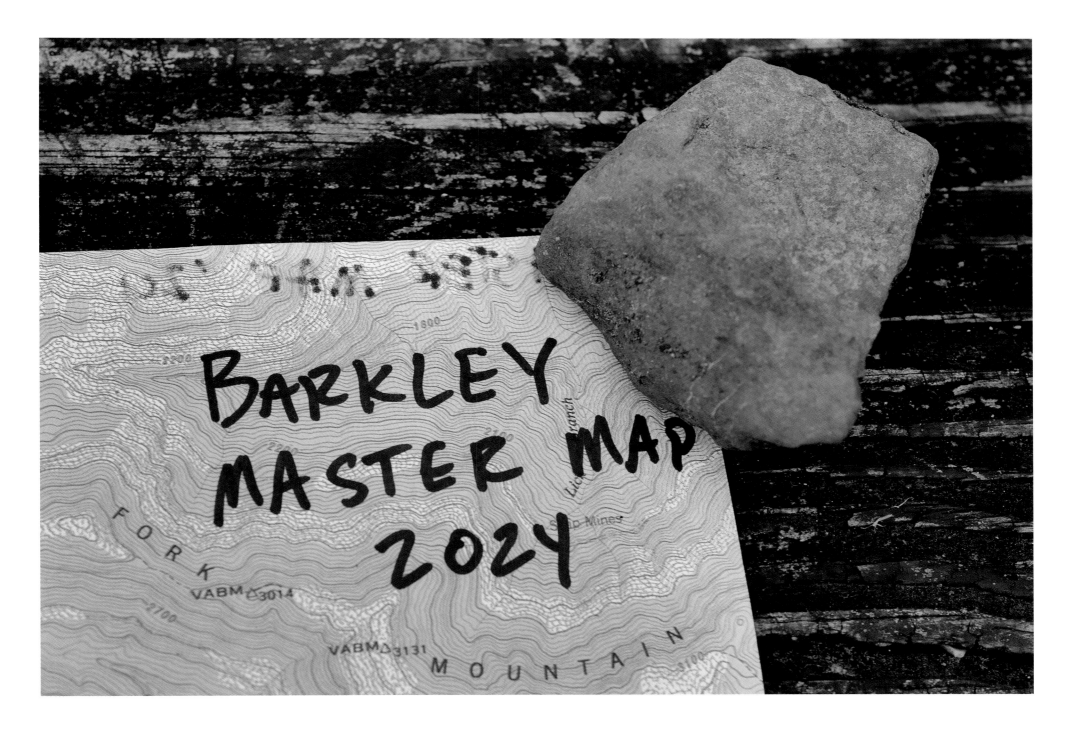

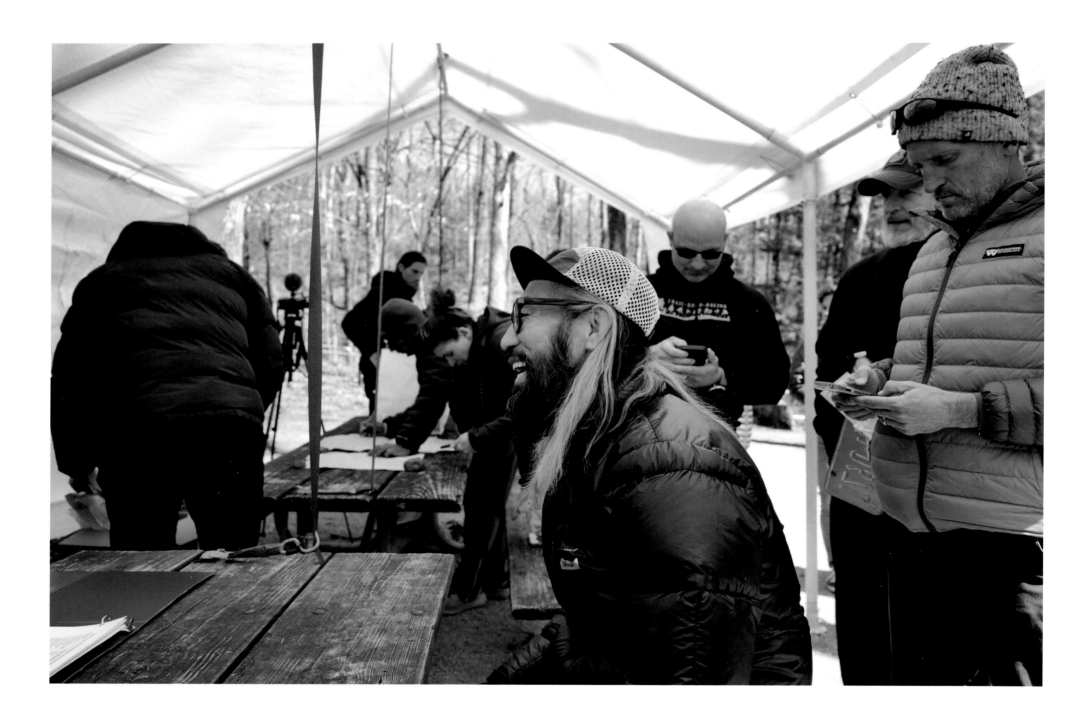

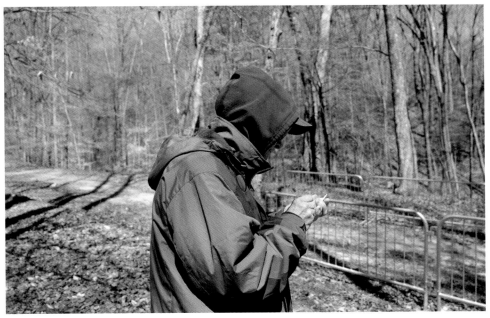

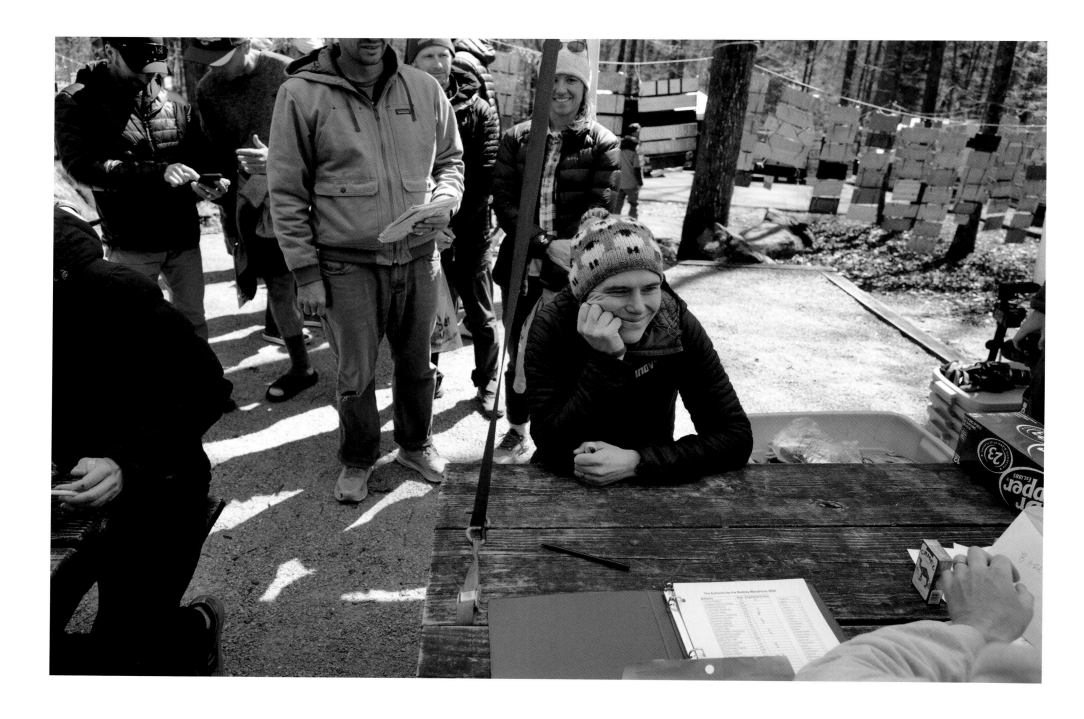

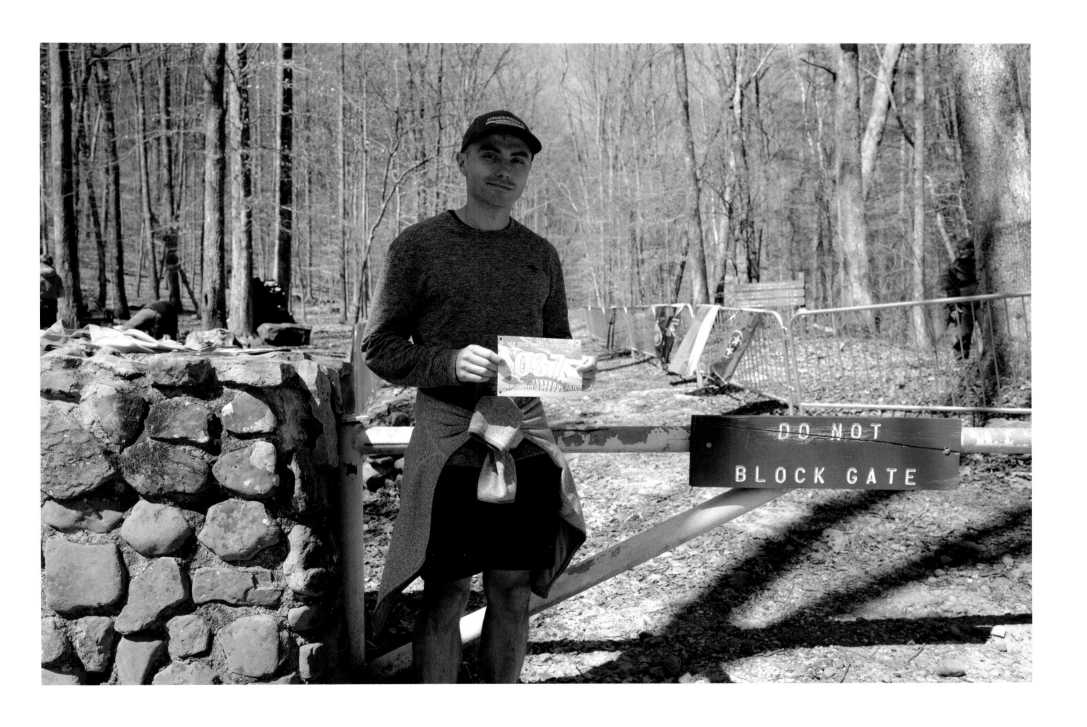

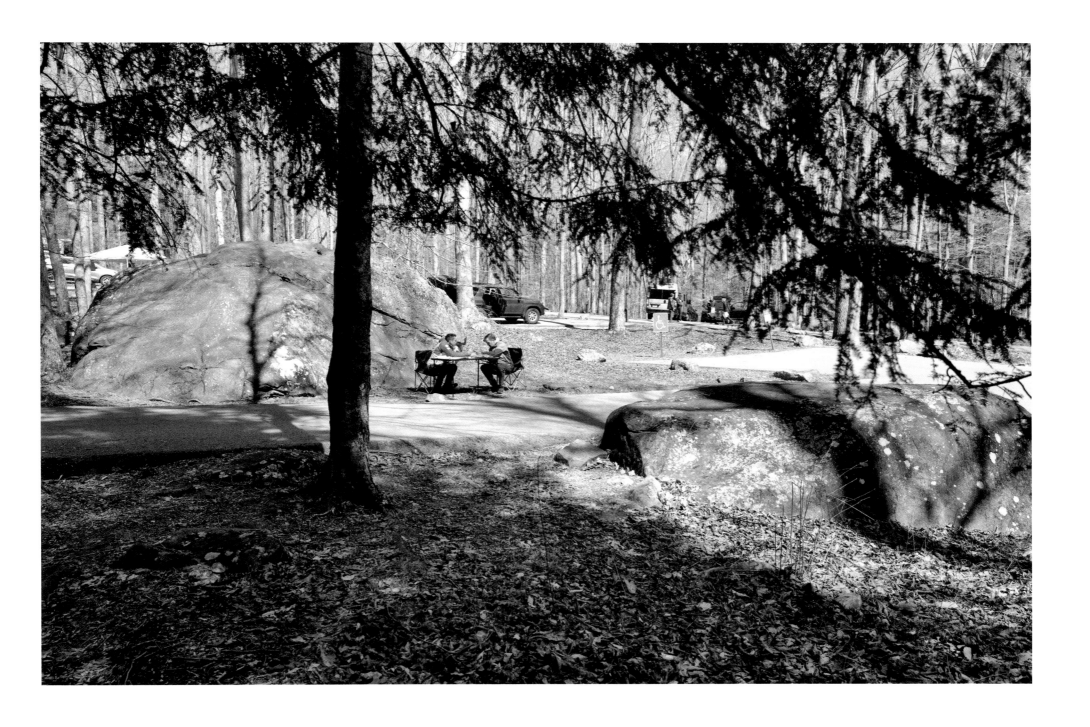

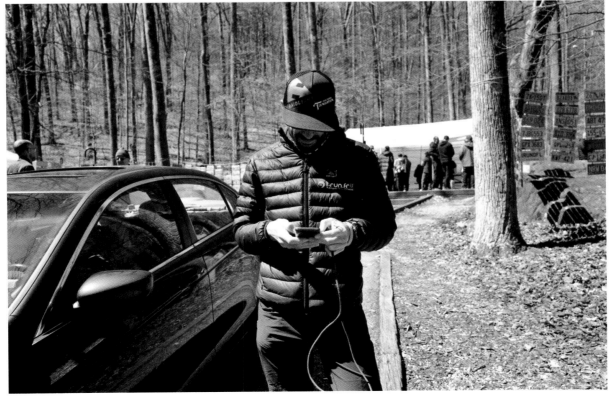

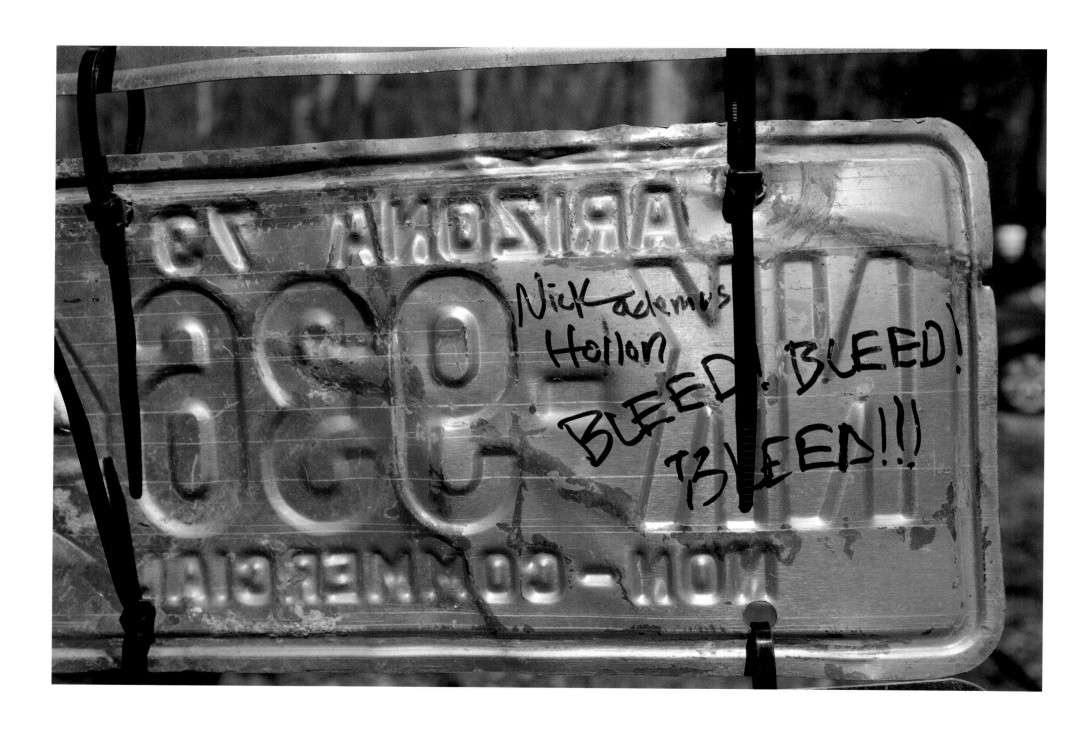

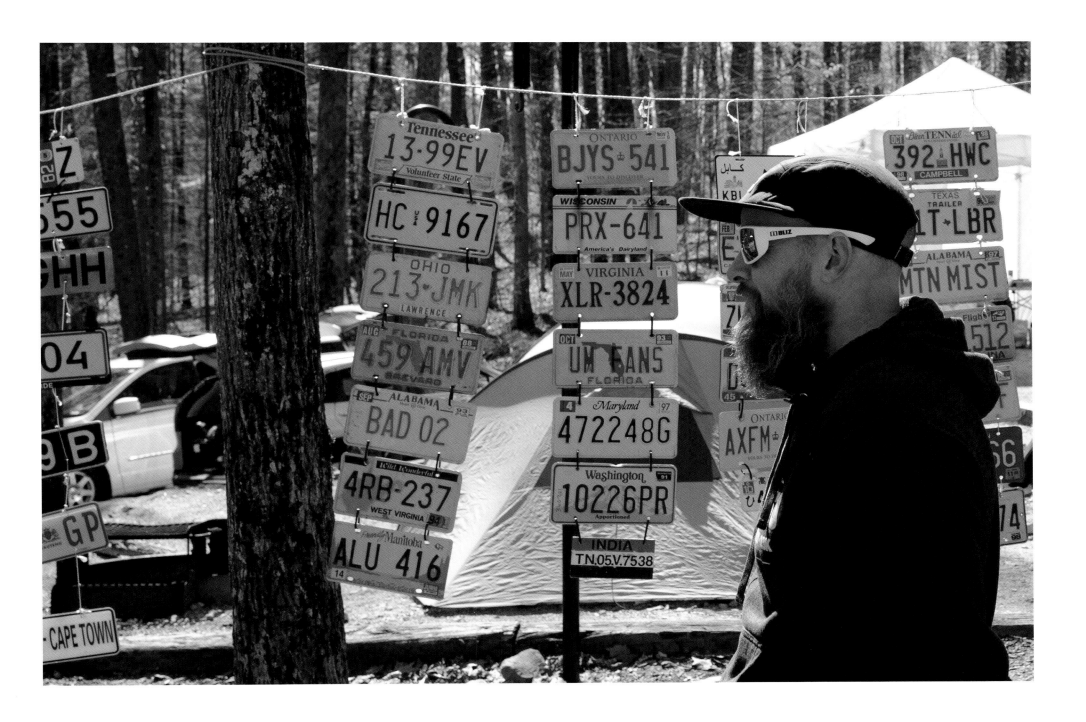

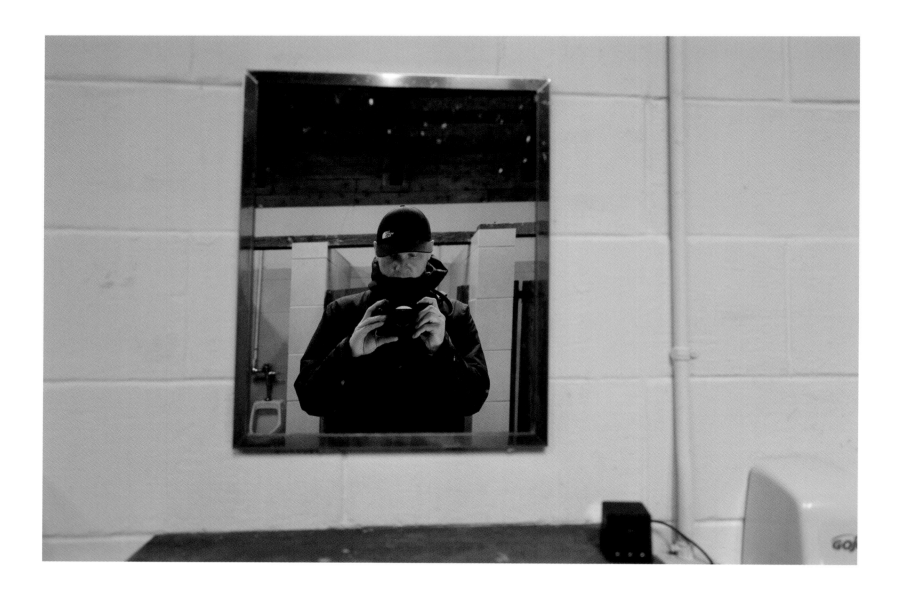

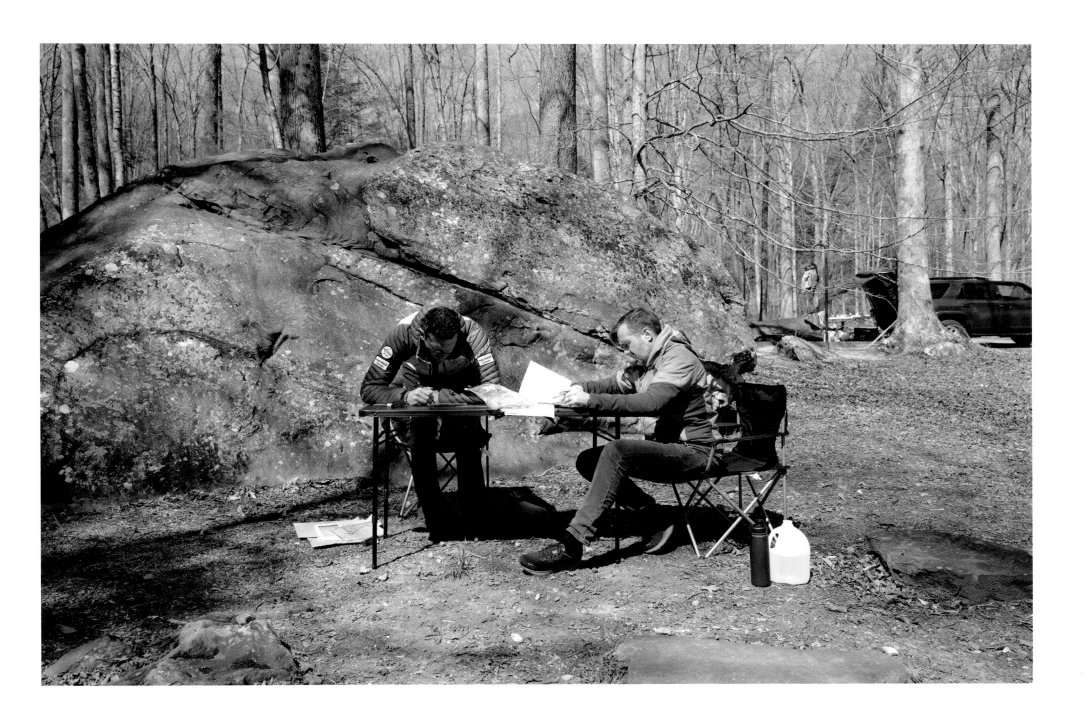

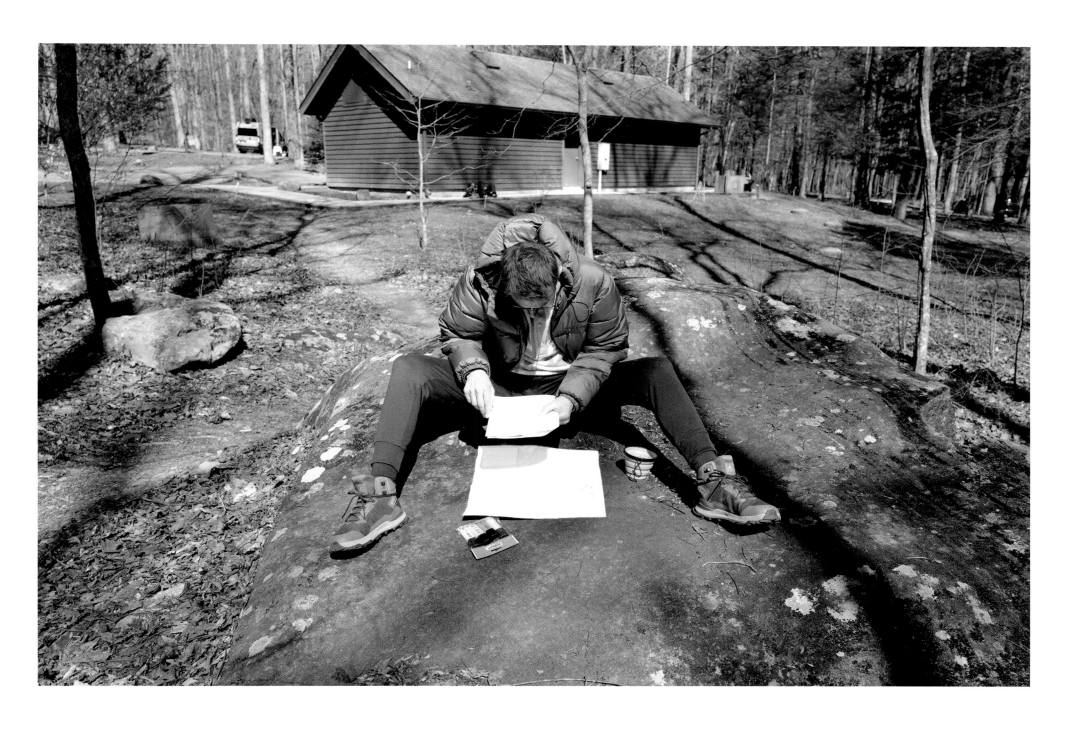

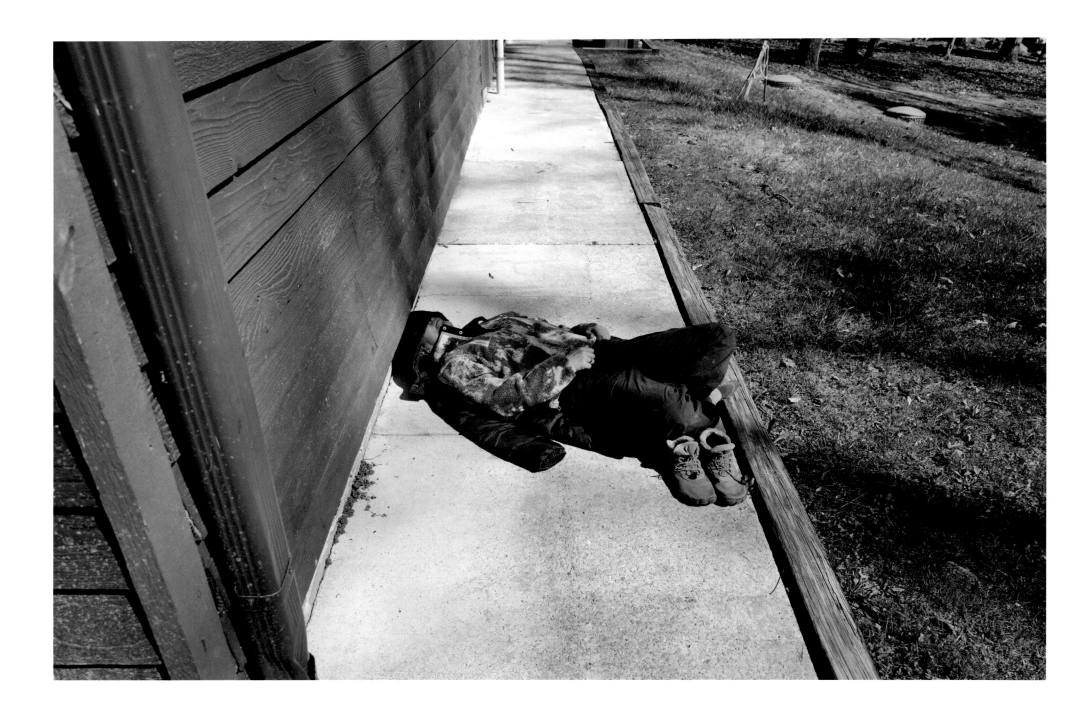

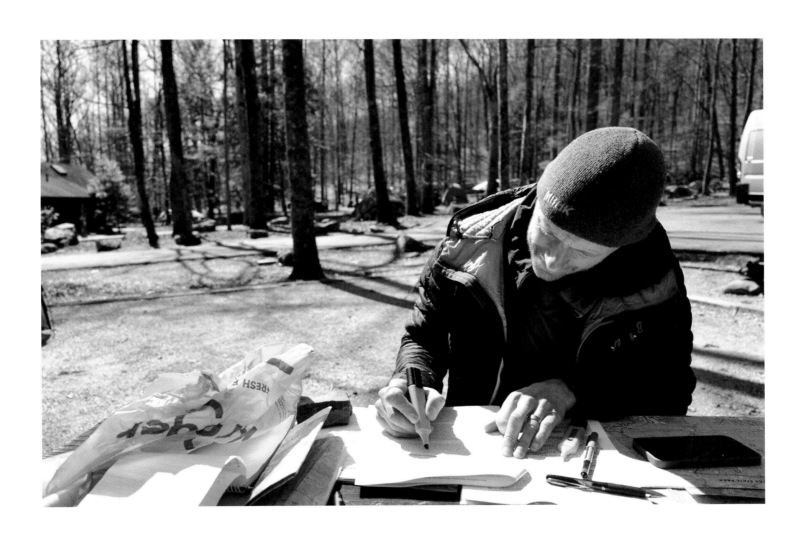

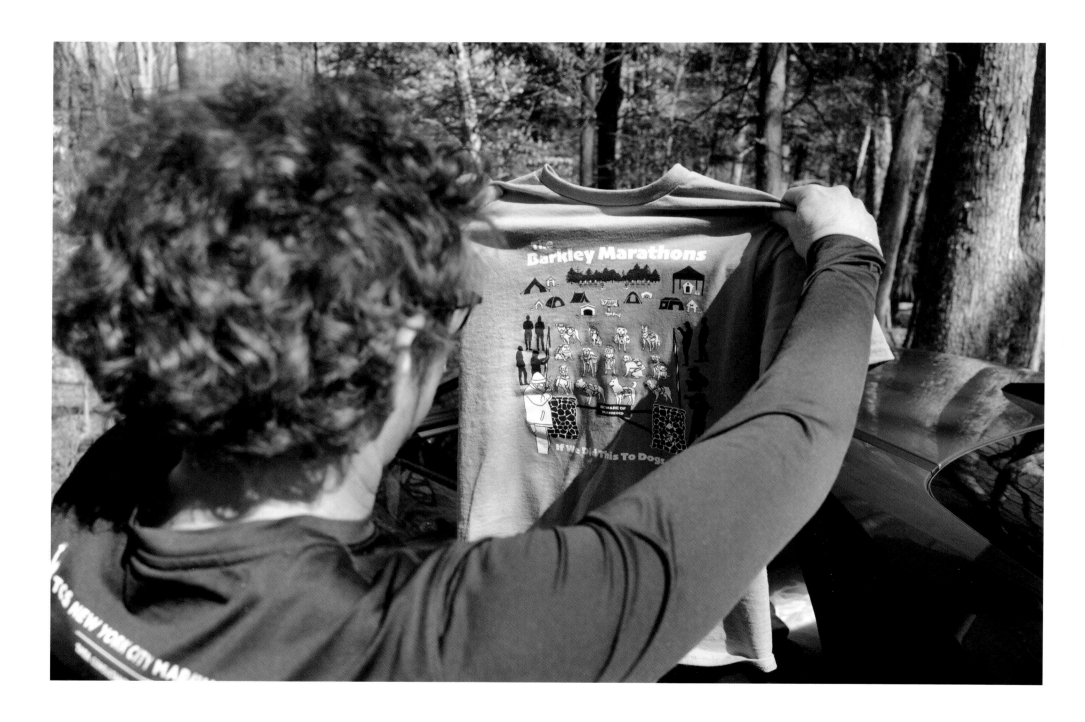

DO NOT BLOCK GATE

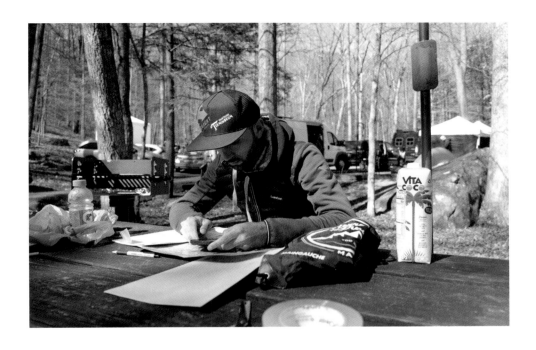

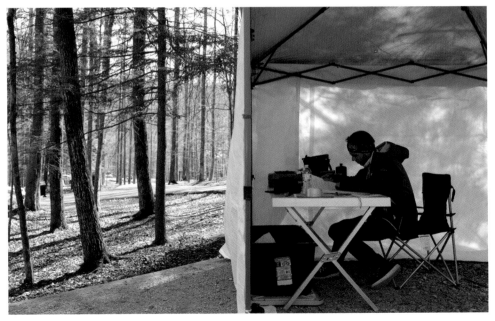

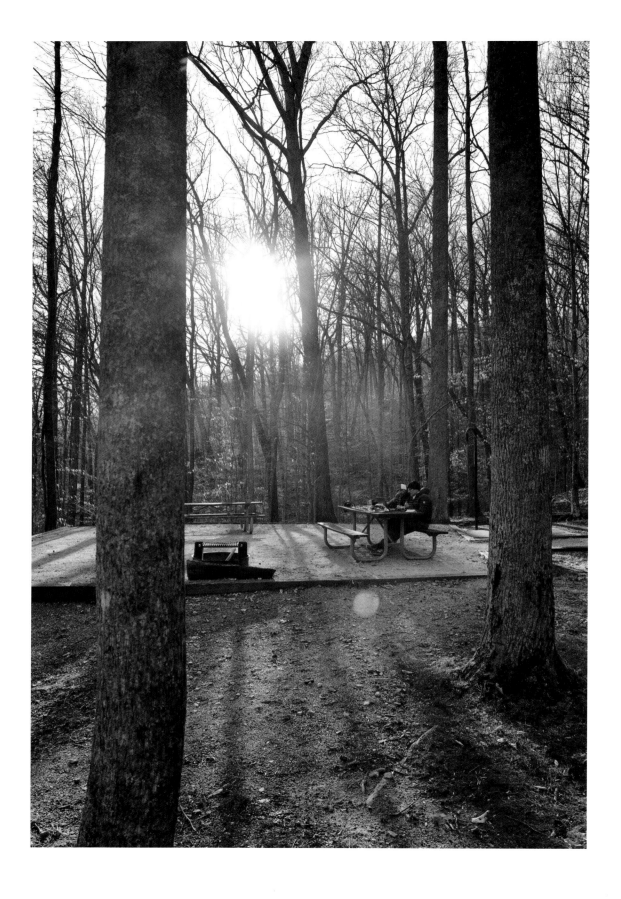

DO NOT BLOCK GATE

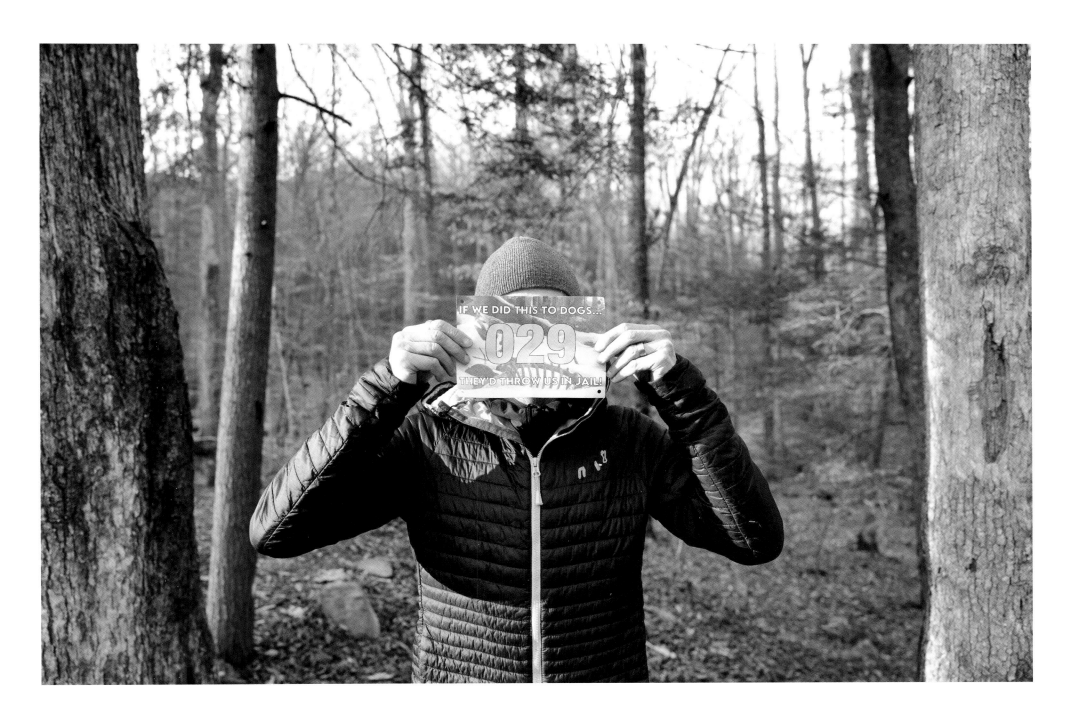

DO NOT BLOCK GATE

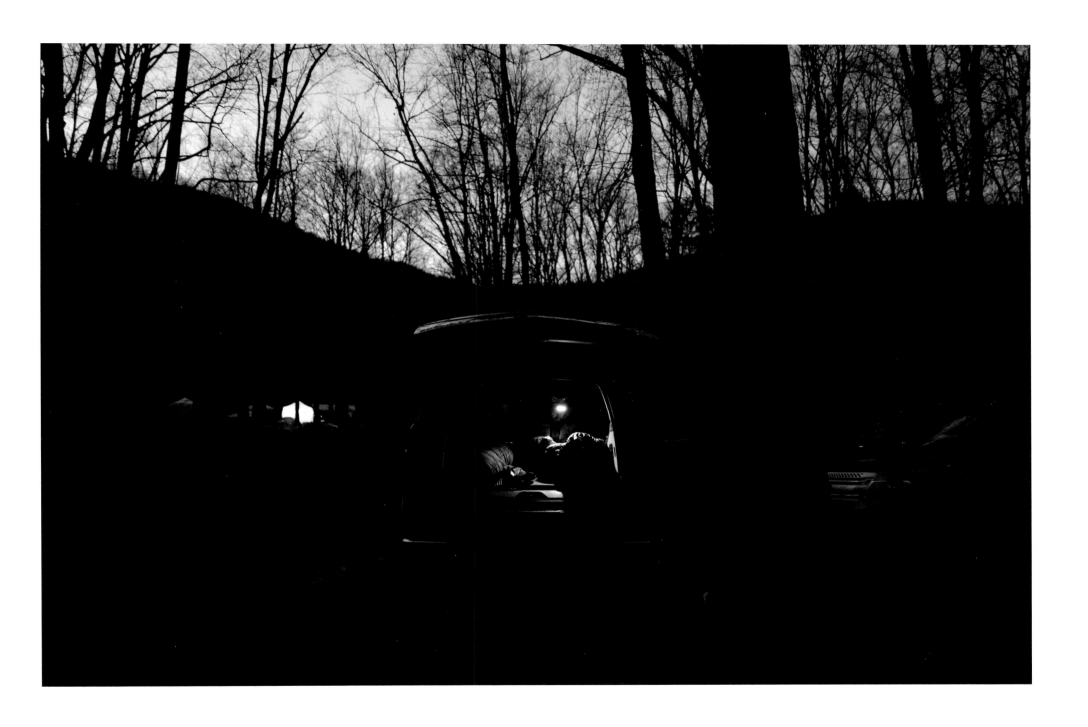

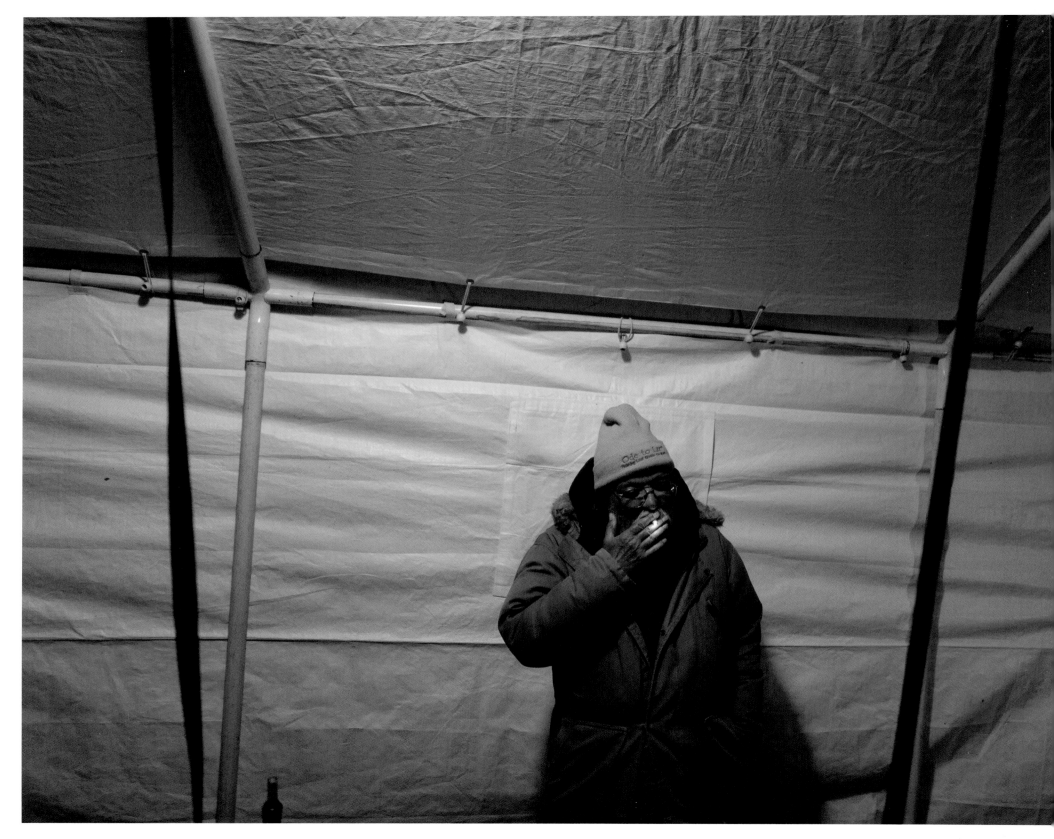

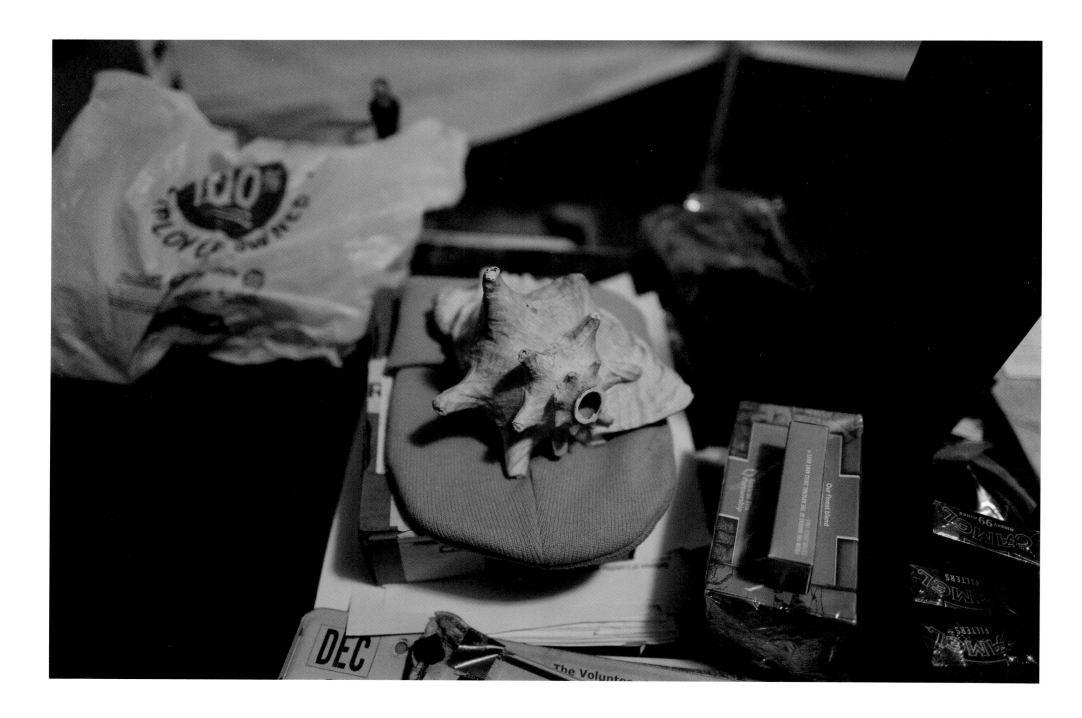

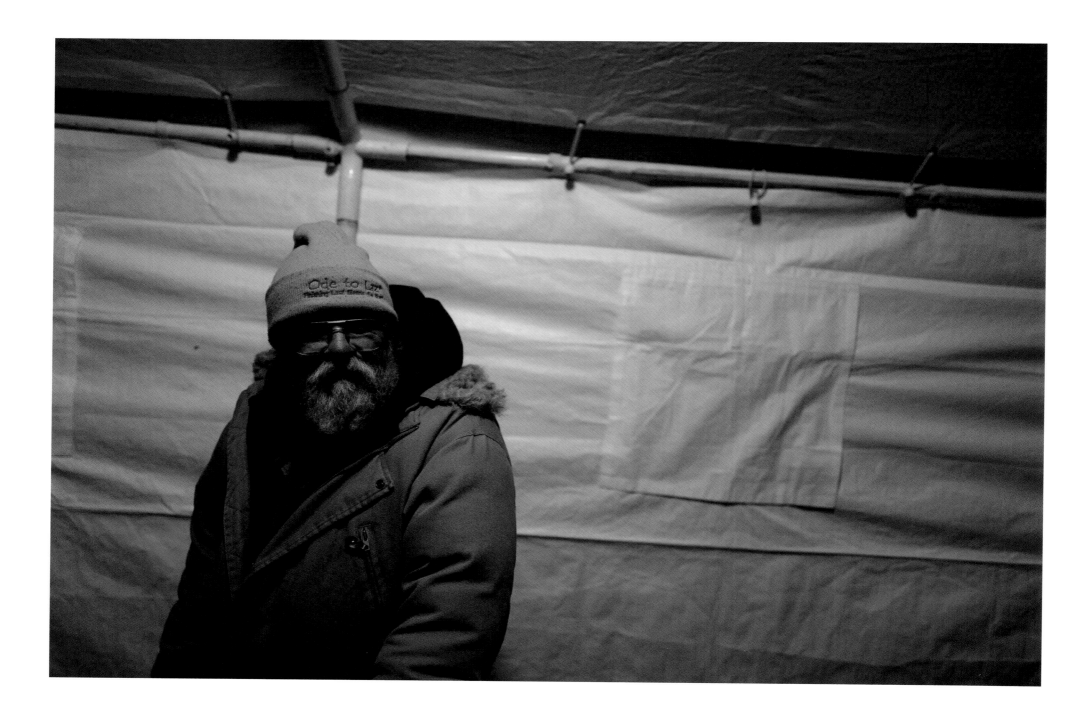

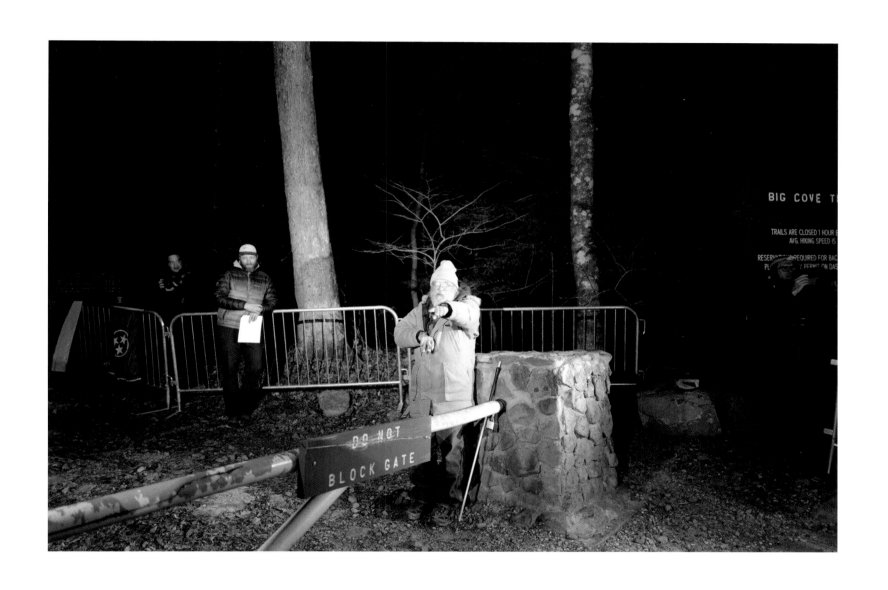

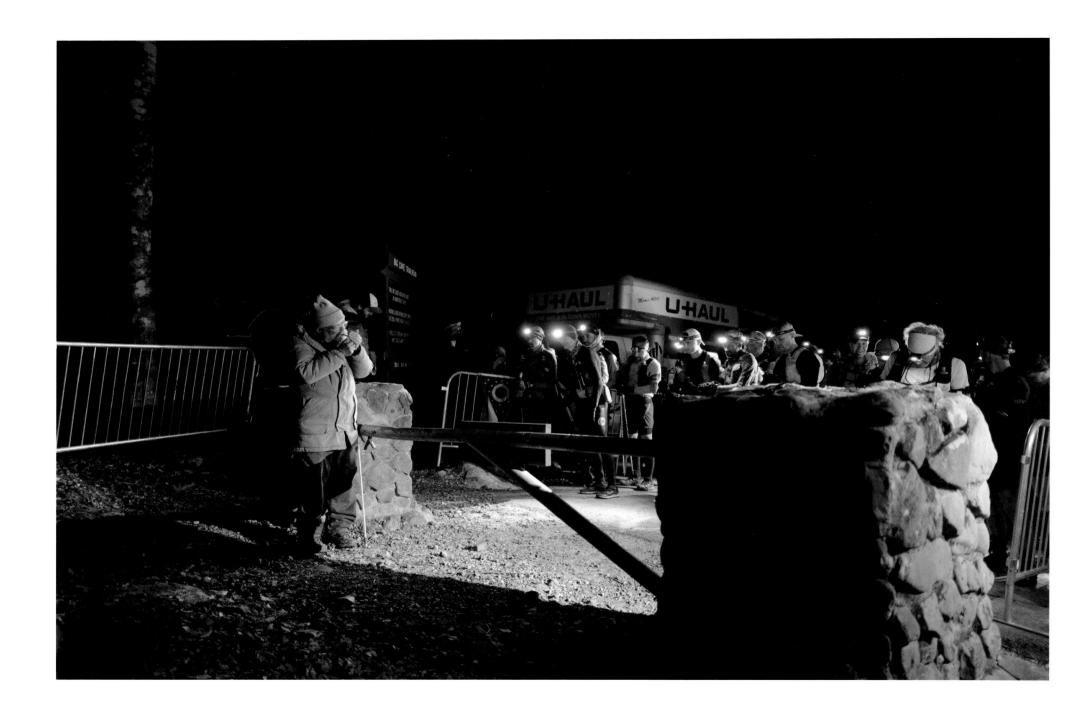

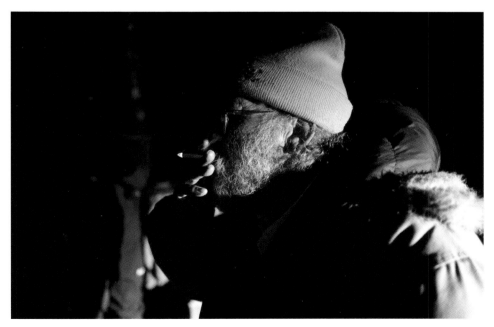

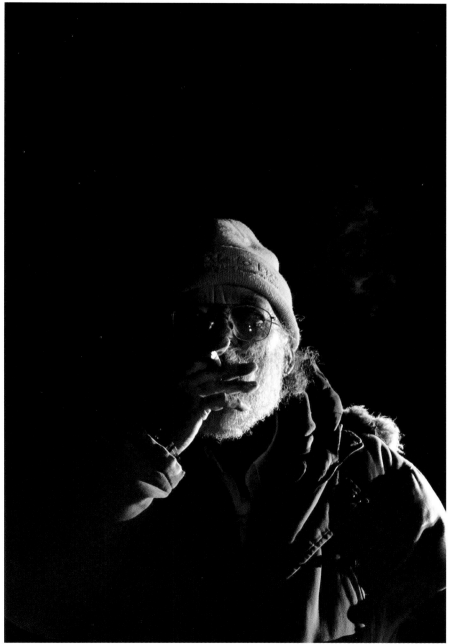

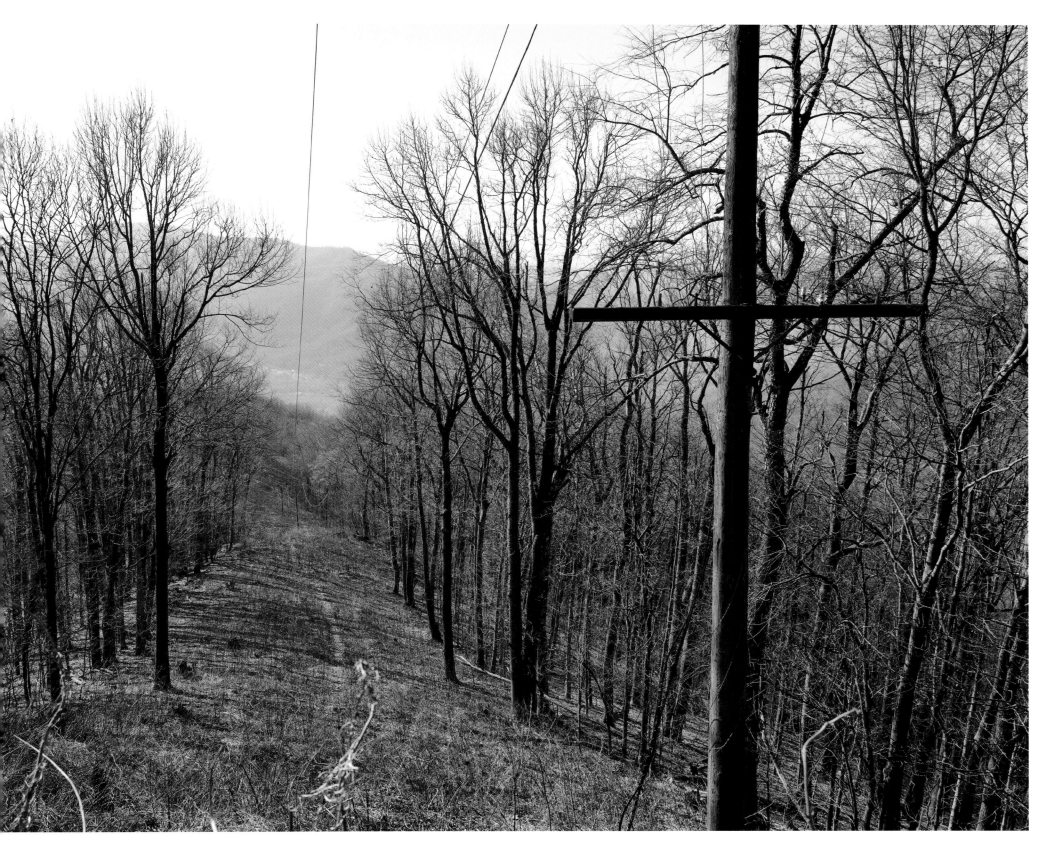

DO NOT BLOCK GATE

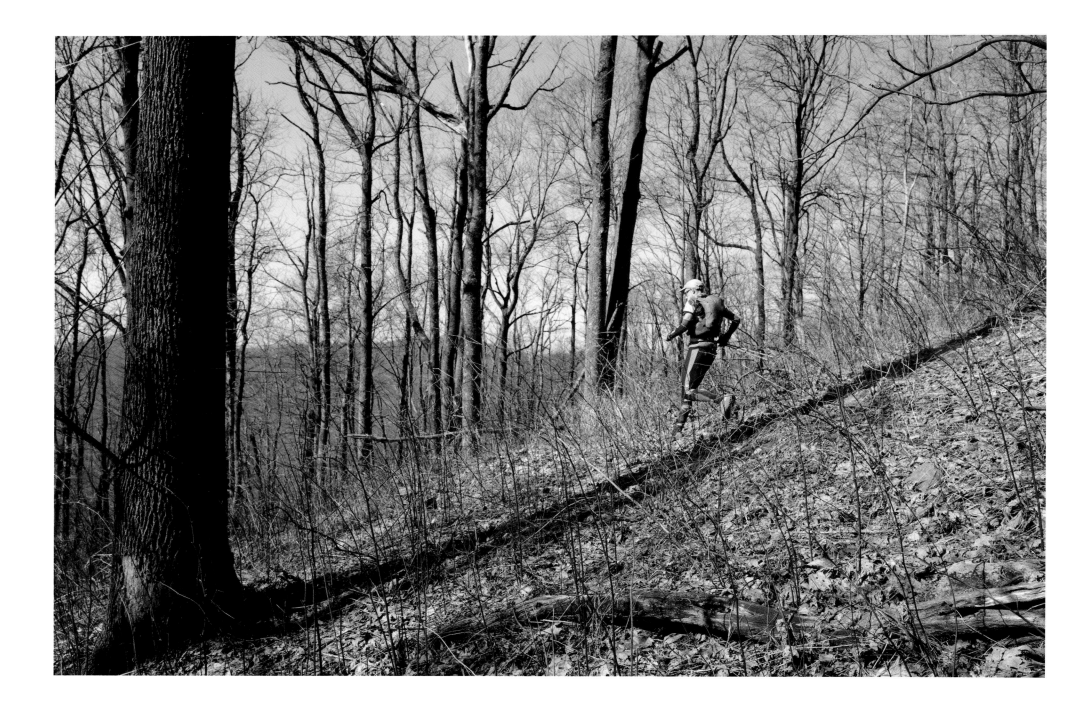

DO NOT BLOCK GATE

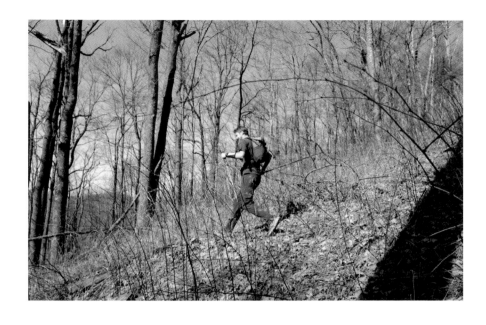

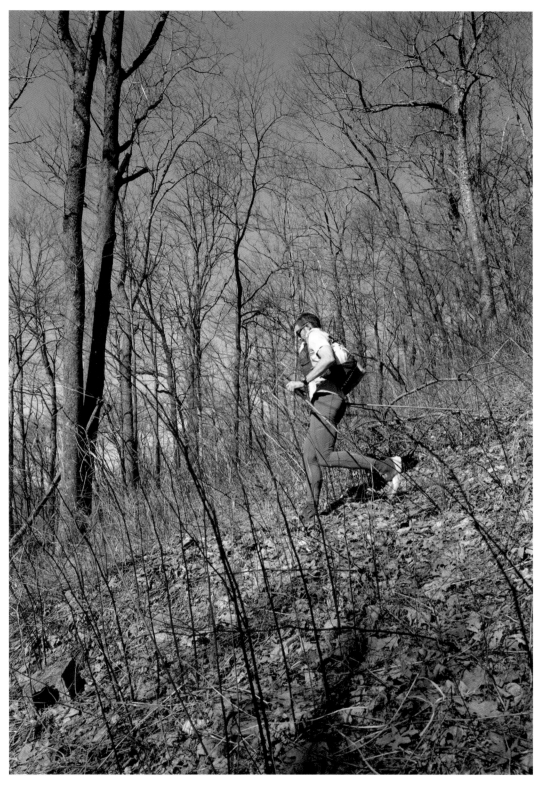

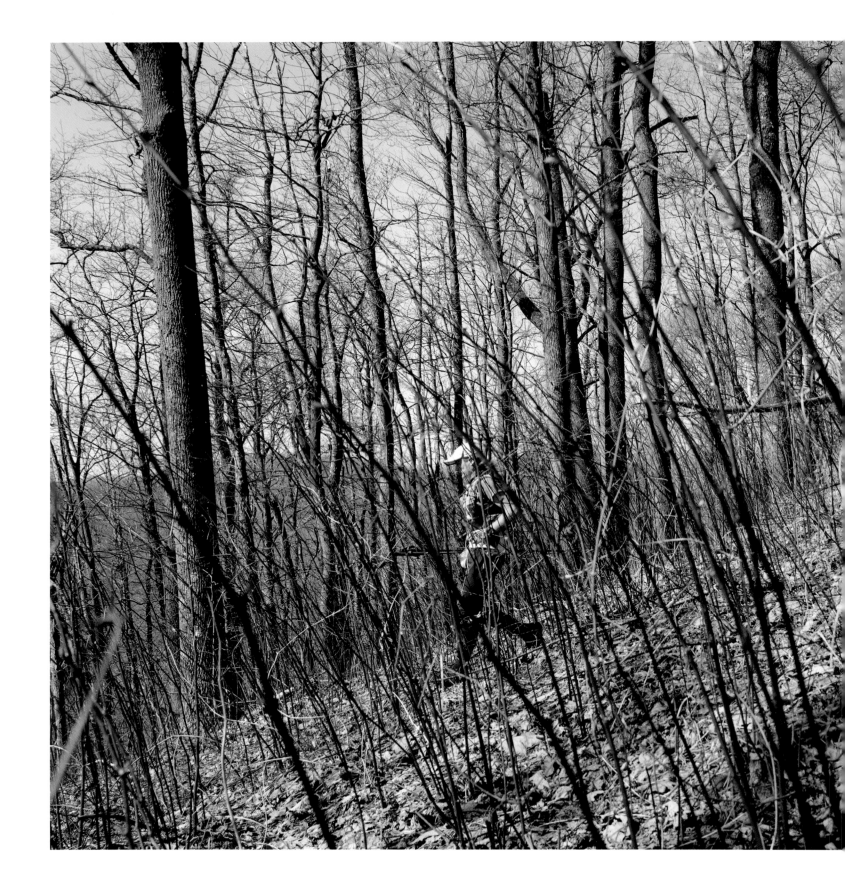

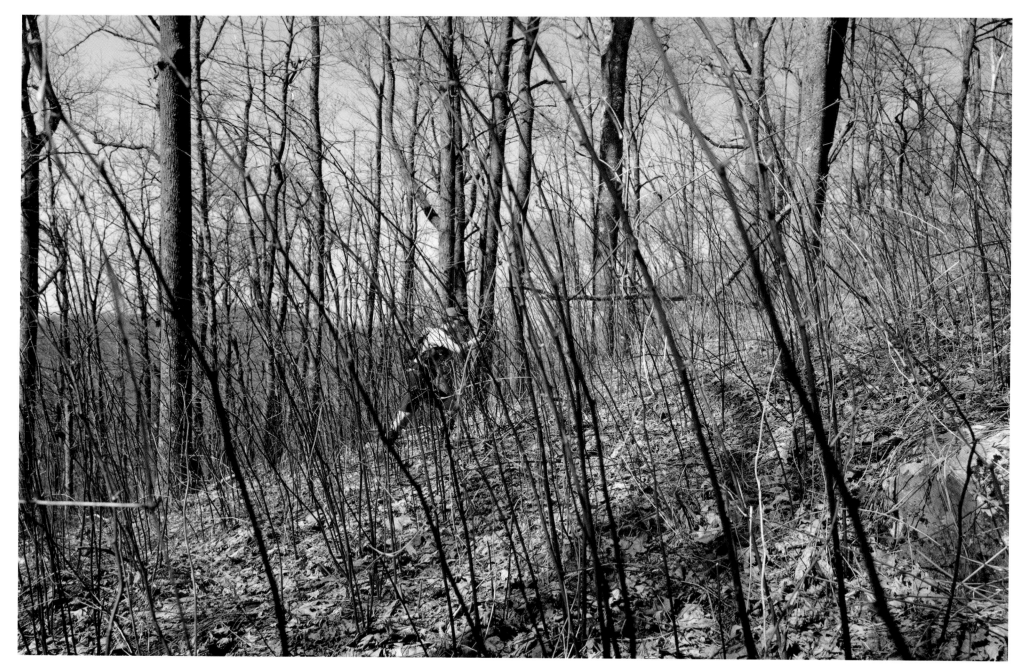

DO NOT BLOCK GATE

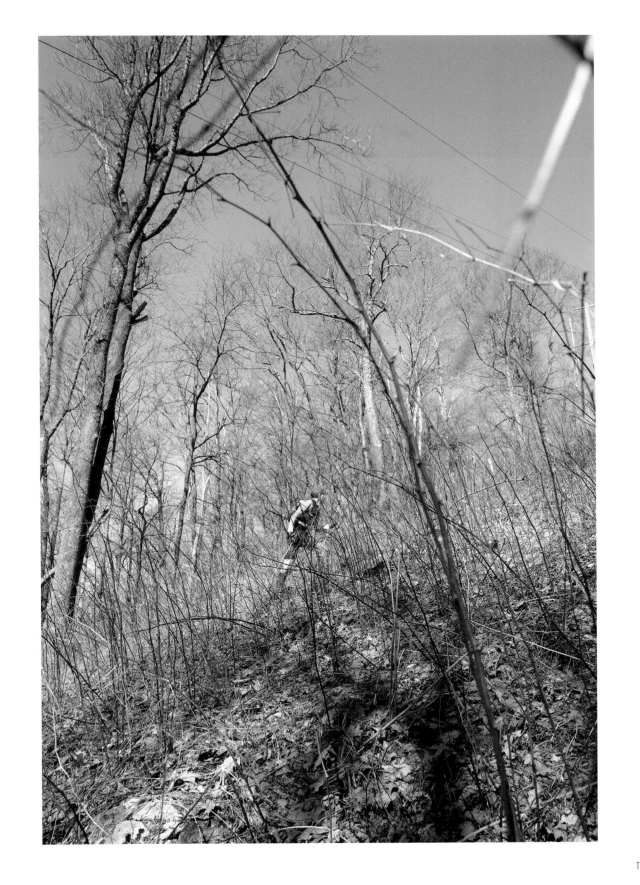

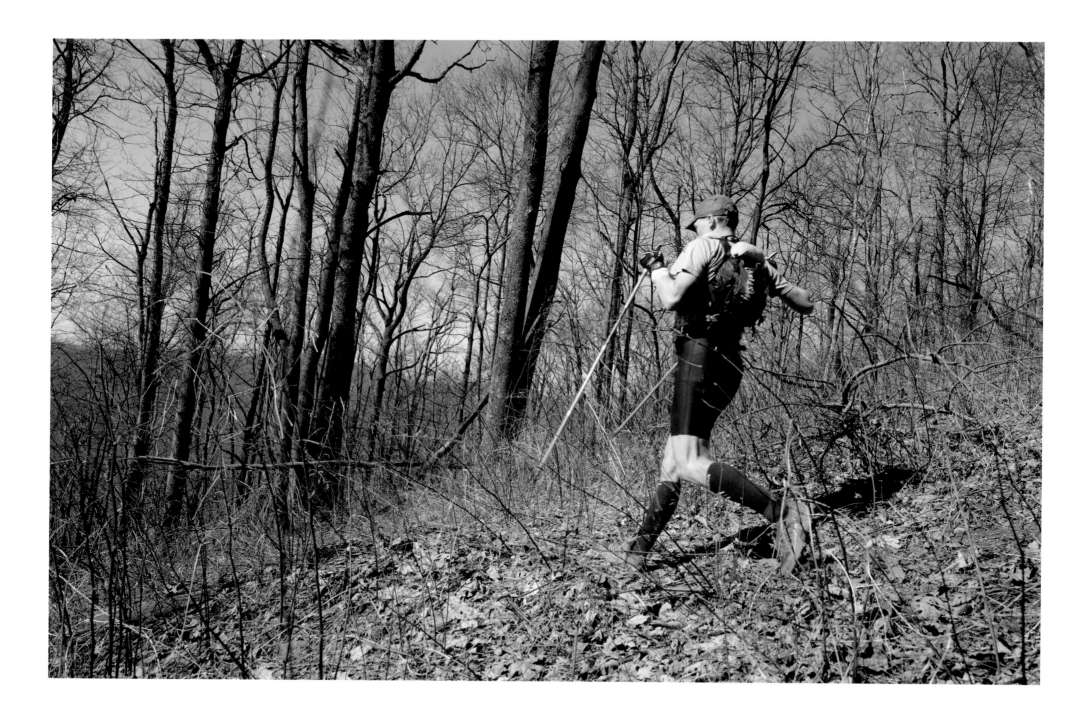

DO NOT BLOCK GATE

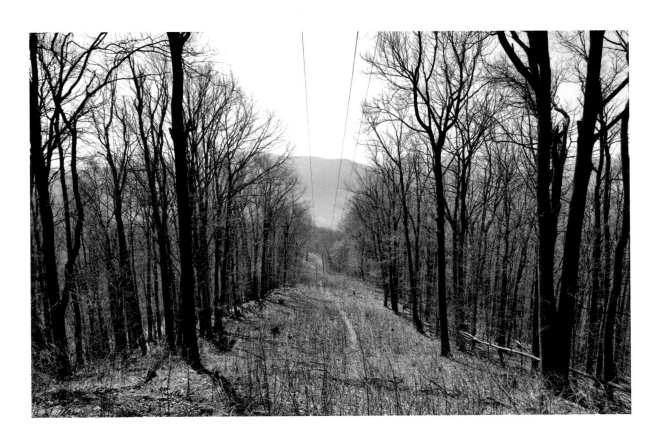

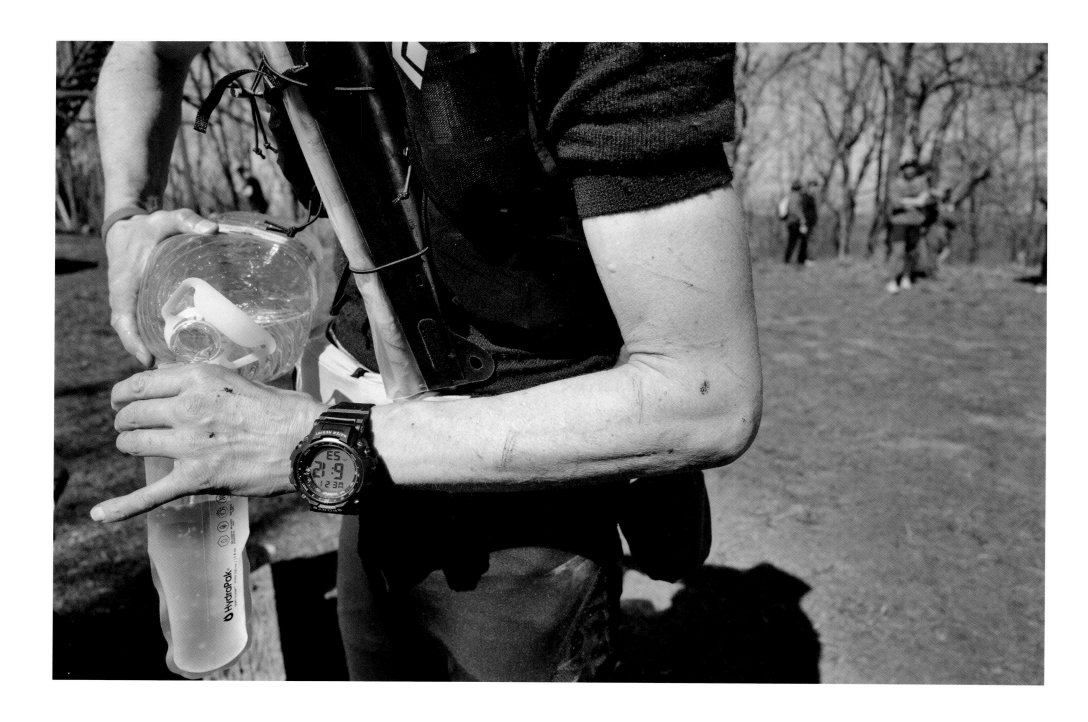

DO NOT BLOCK GATE

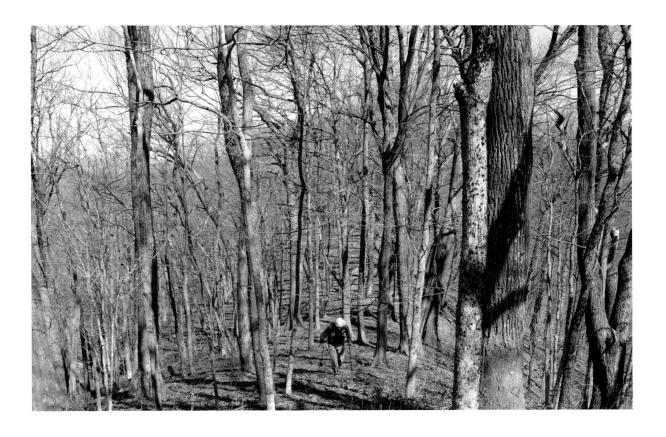

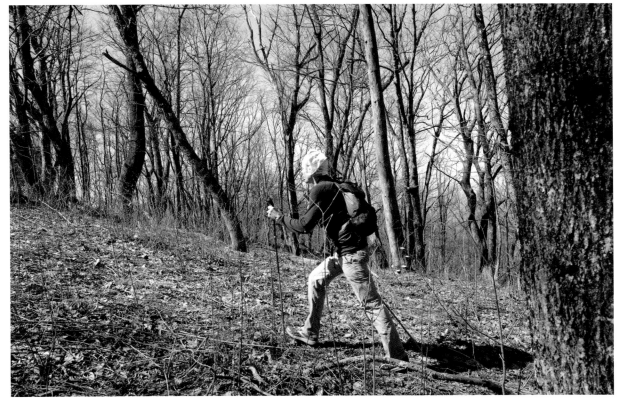

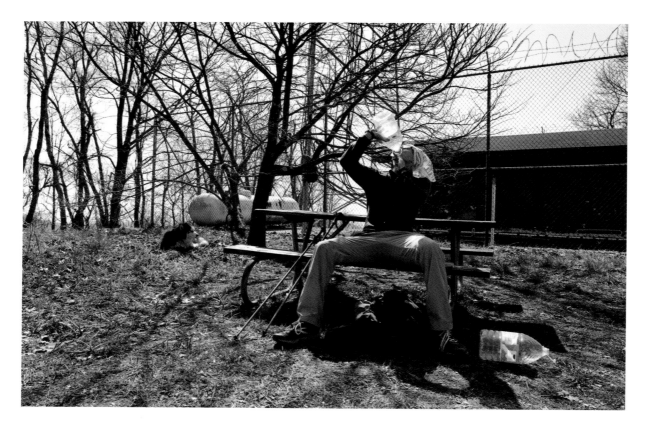

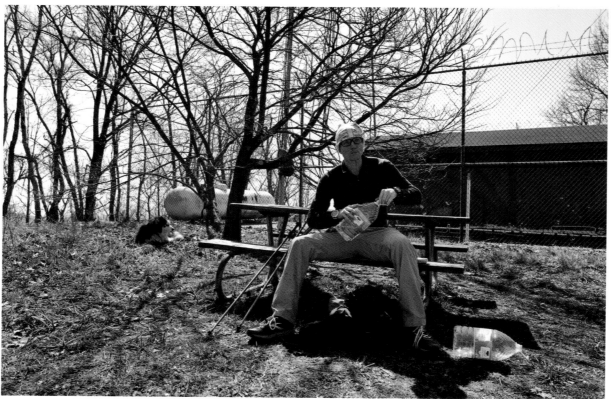

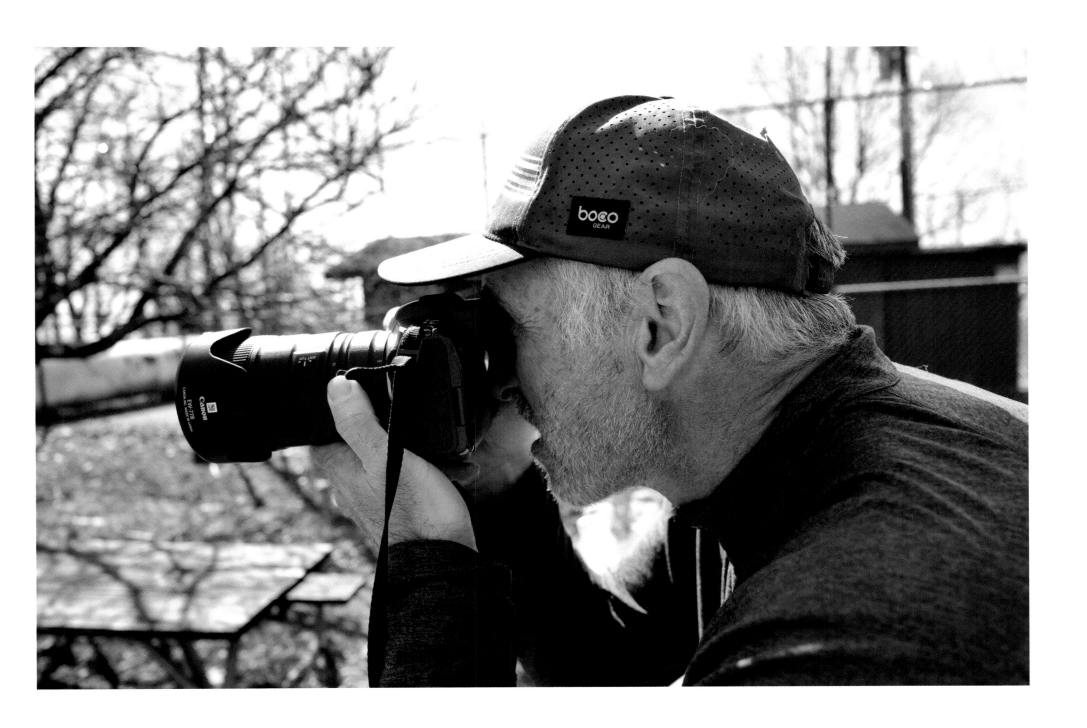

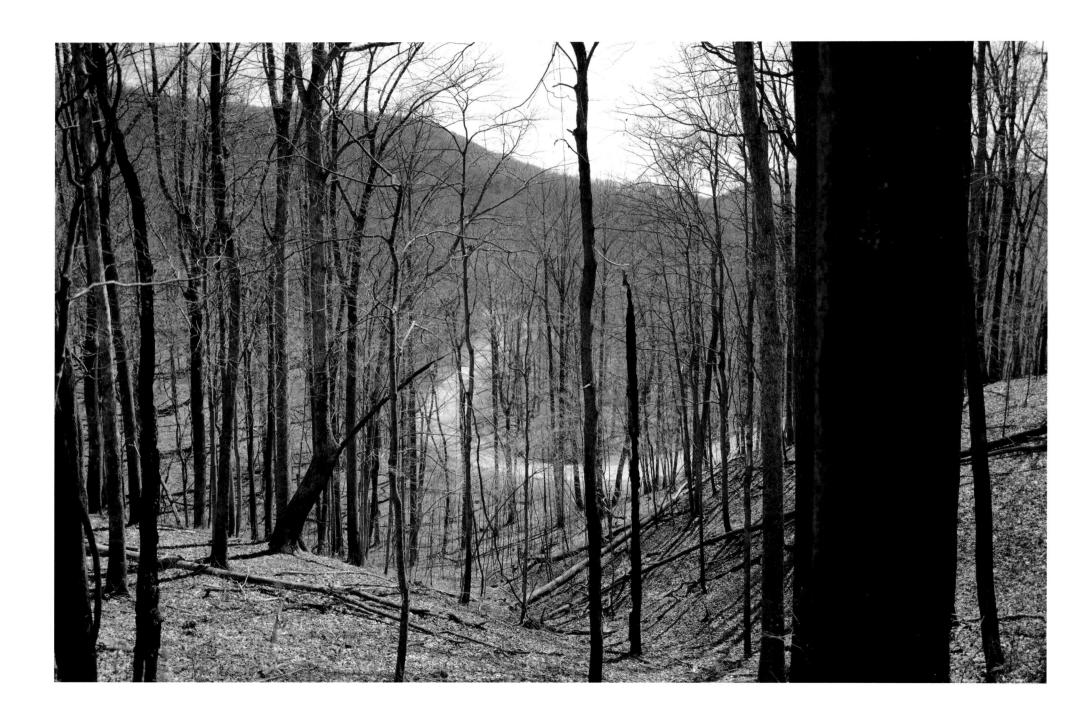

DO NOT BLOCK GATE

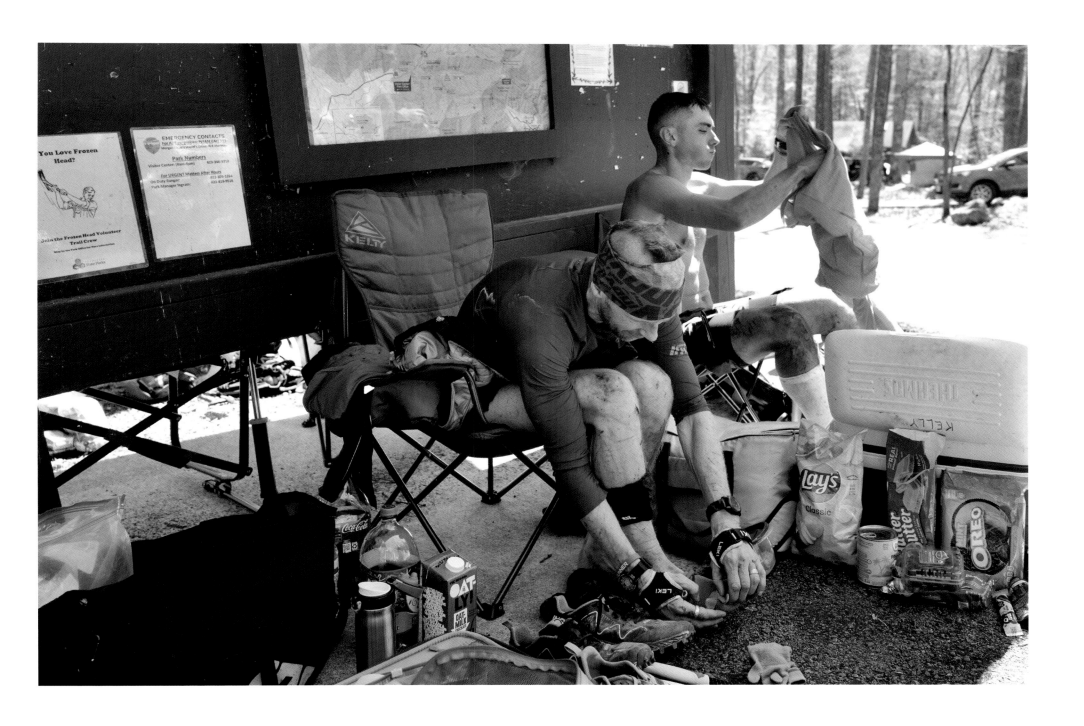

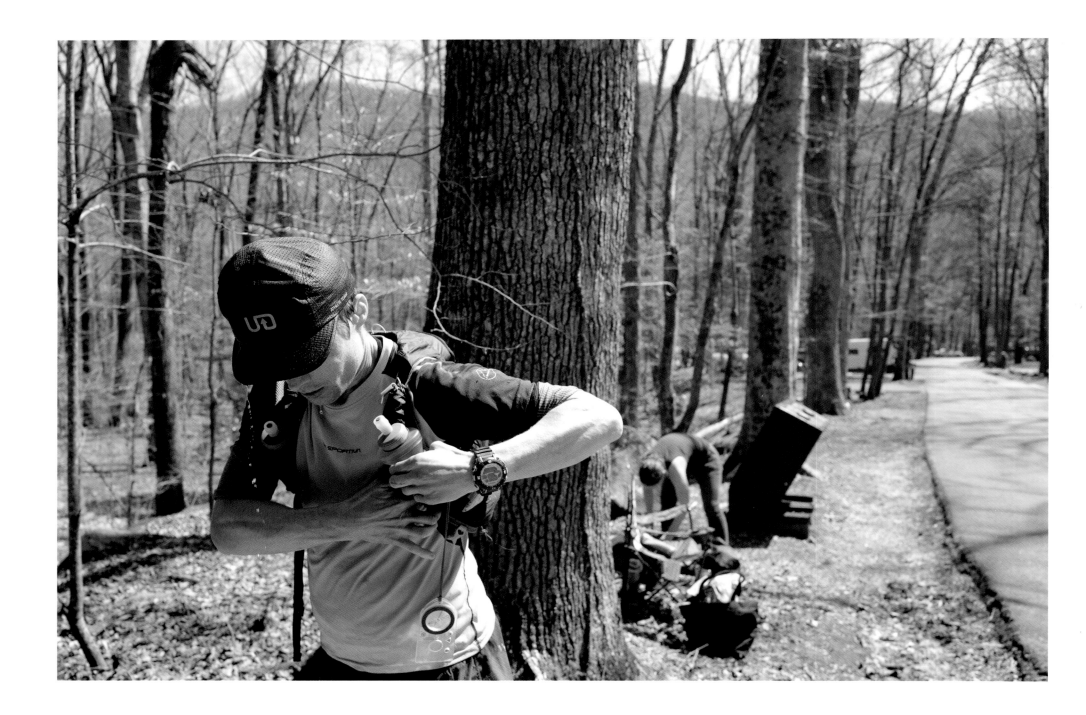

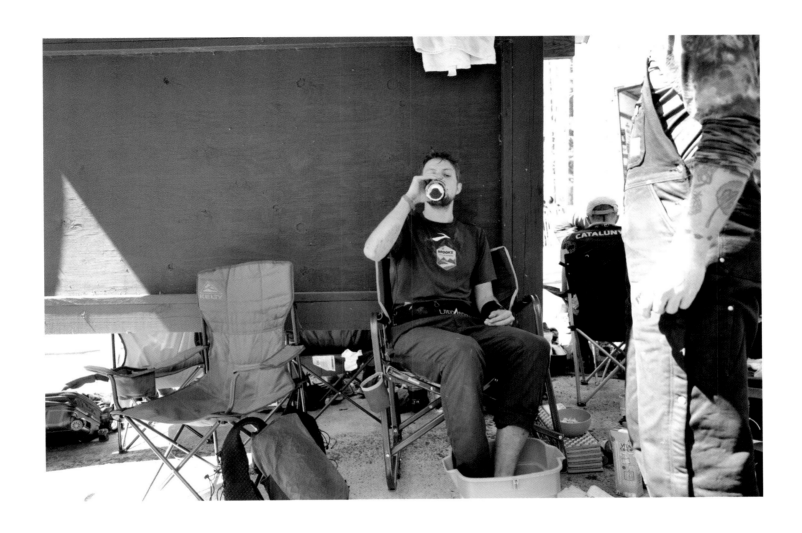

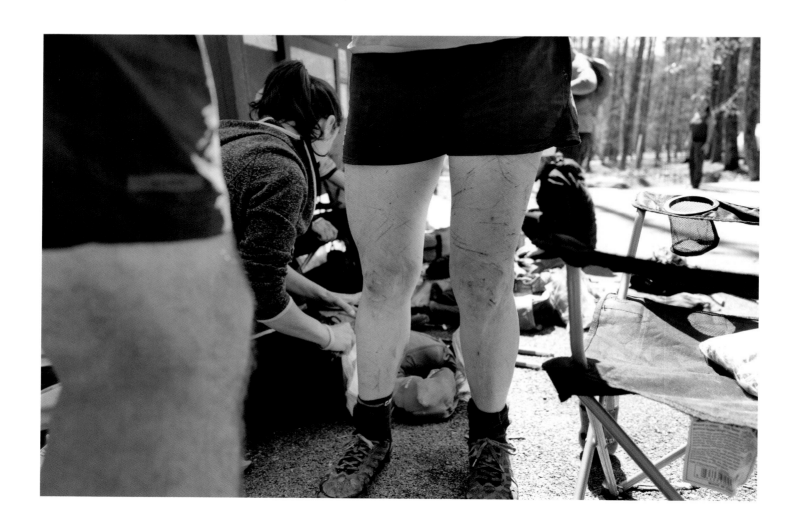

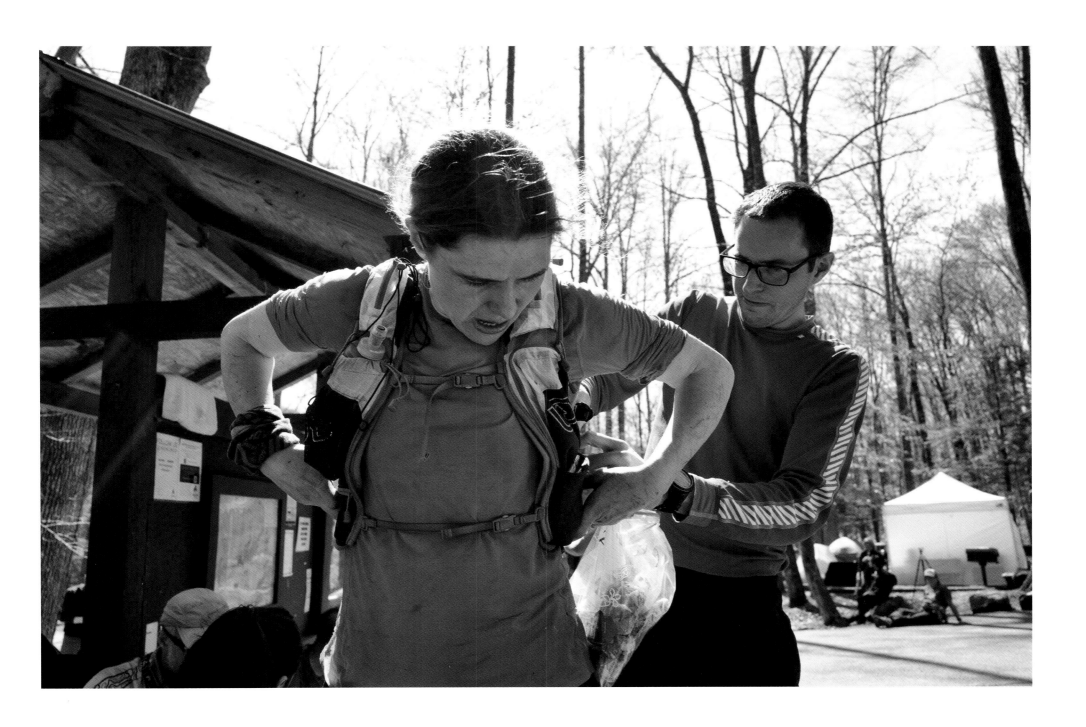

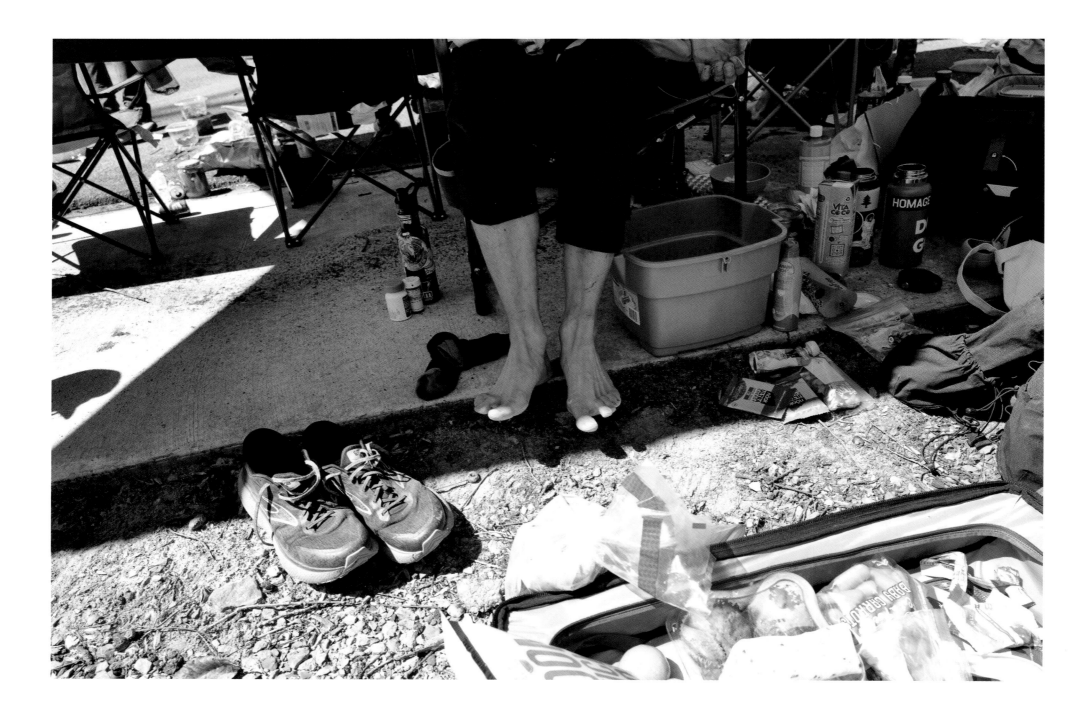

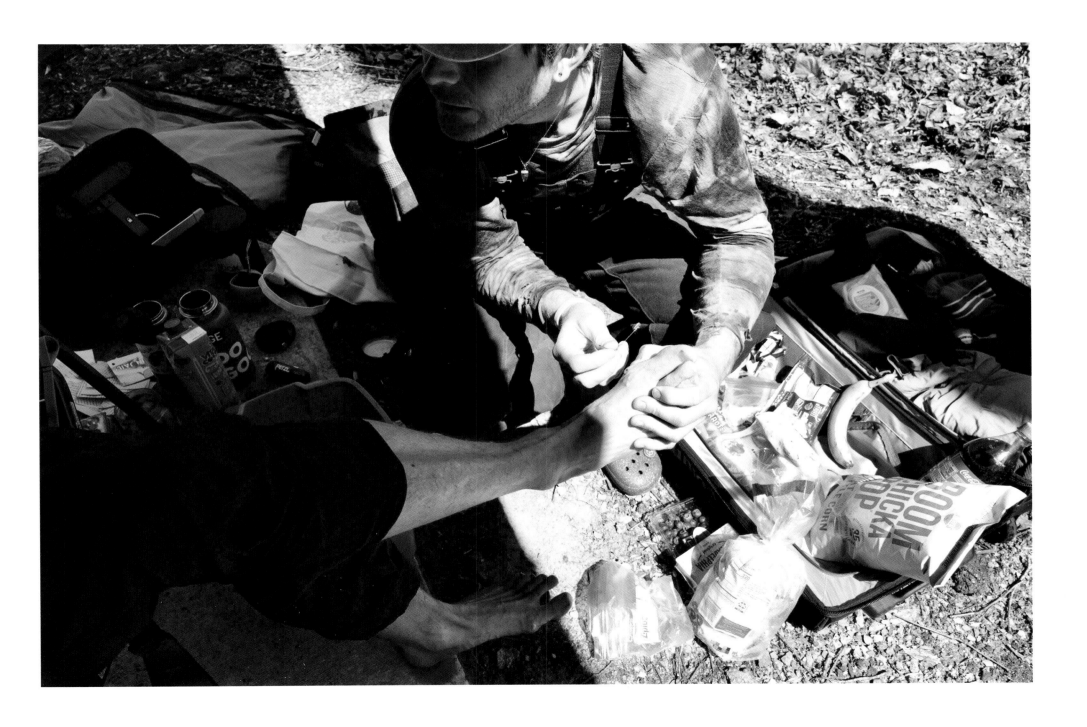

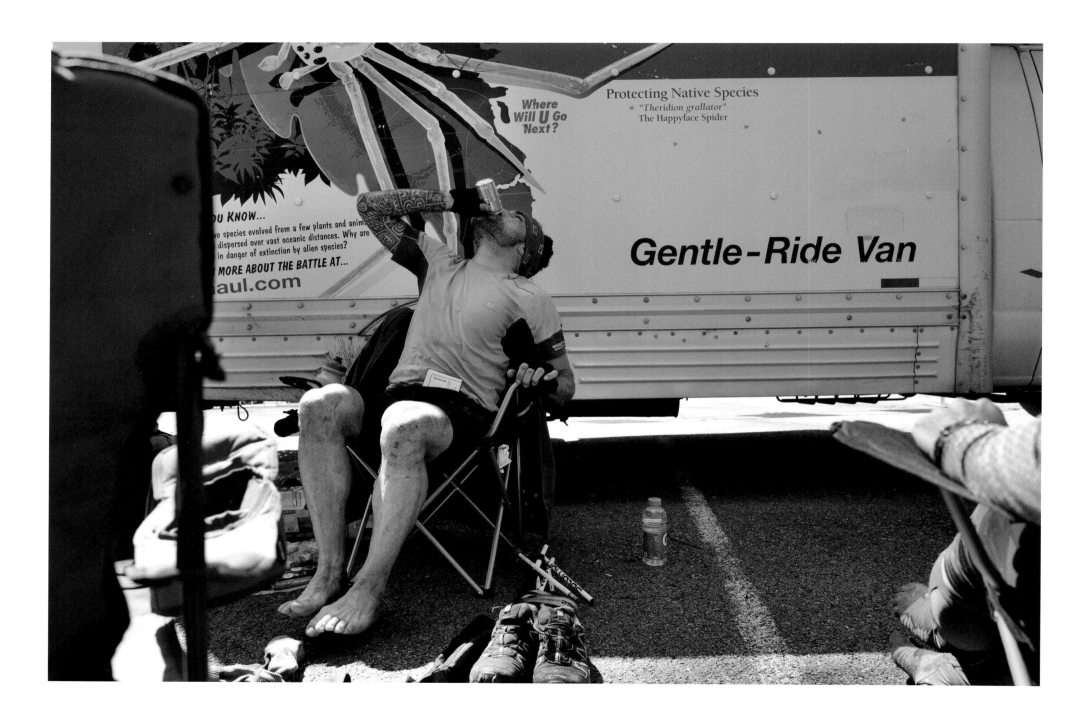

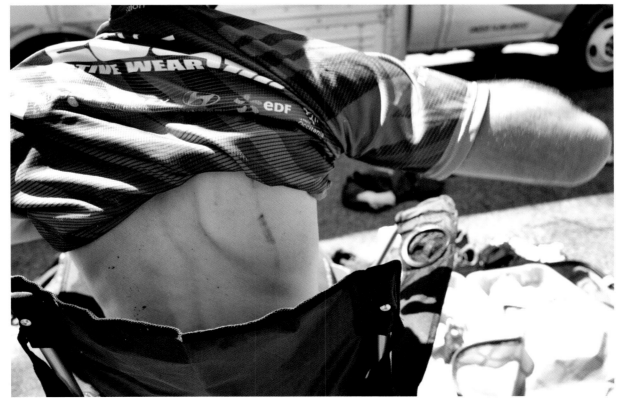

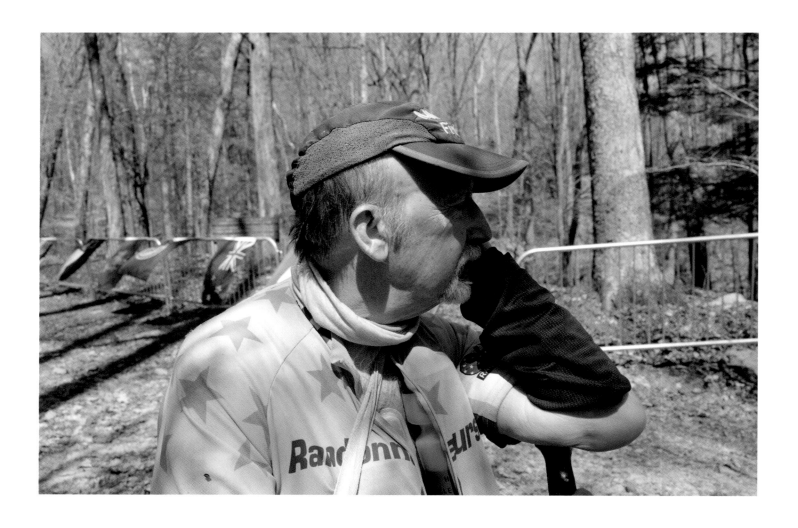

DO NOT BLOCK GATE

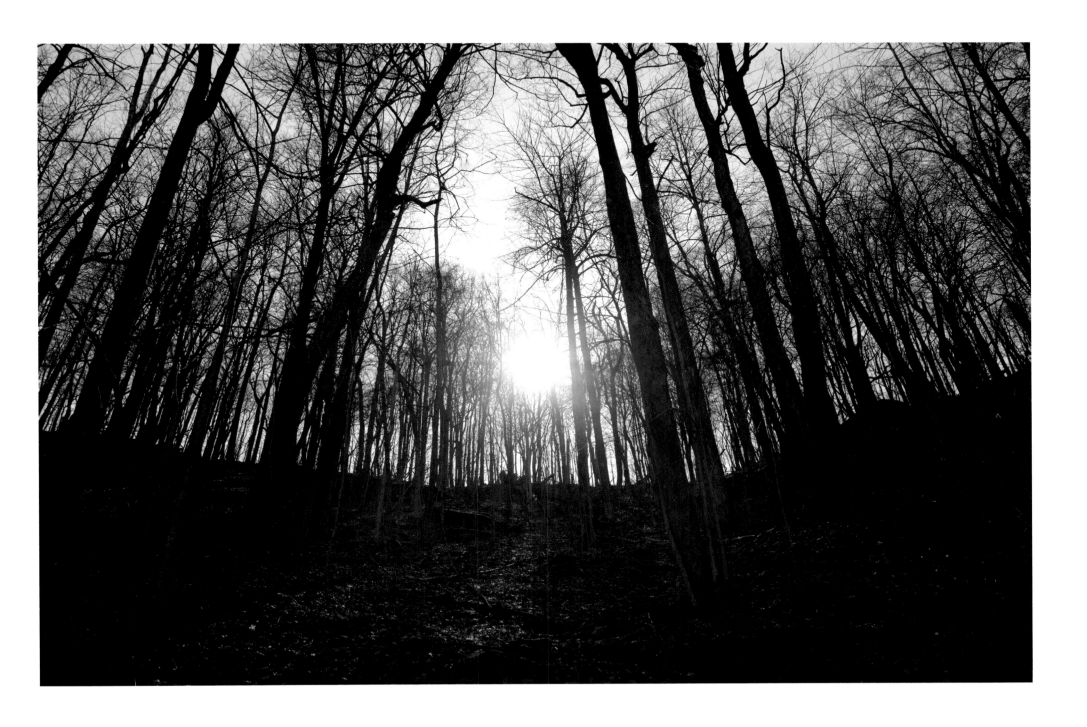

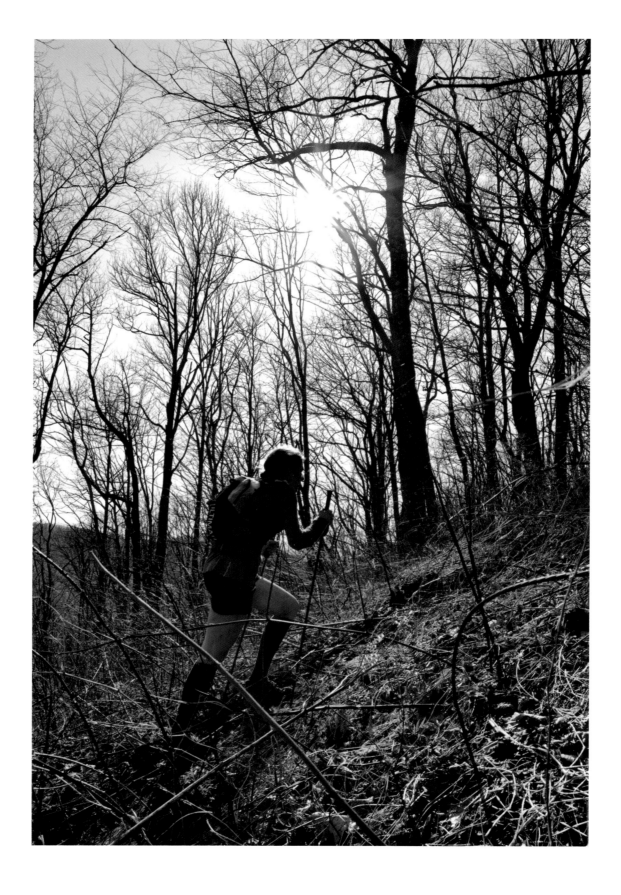

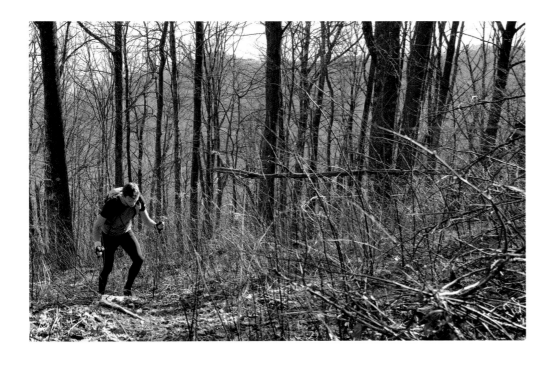

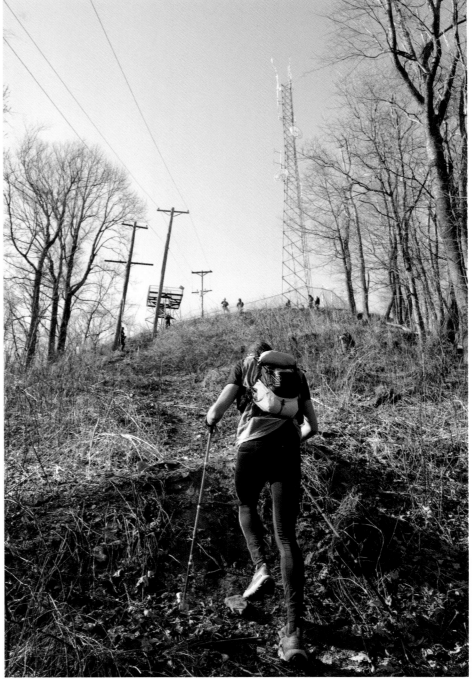

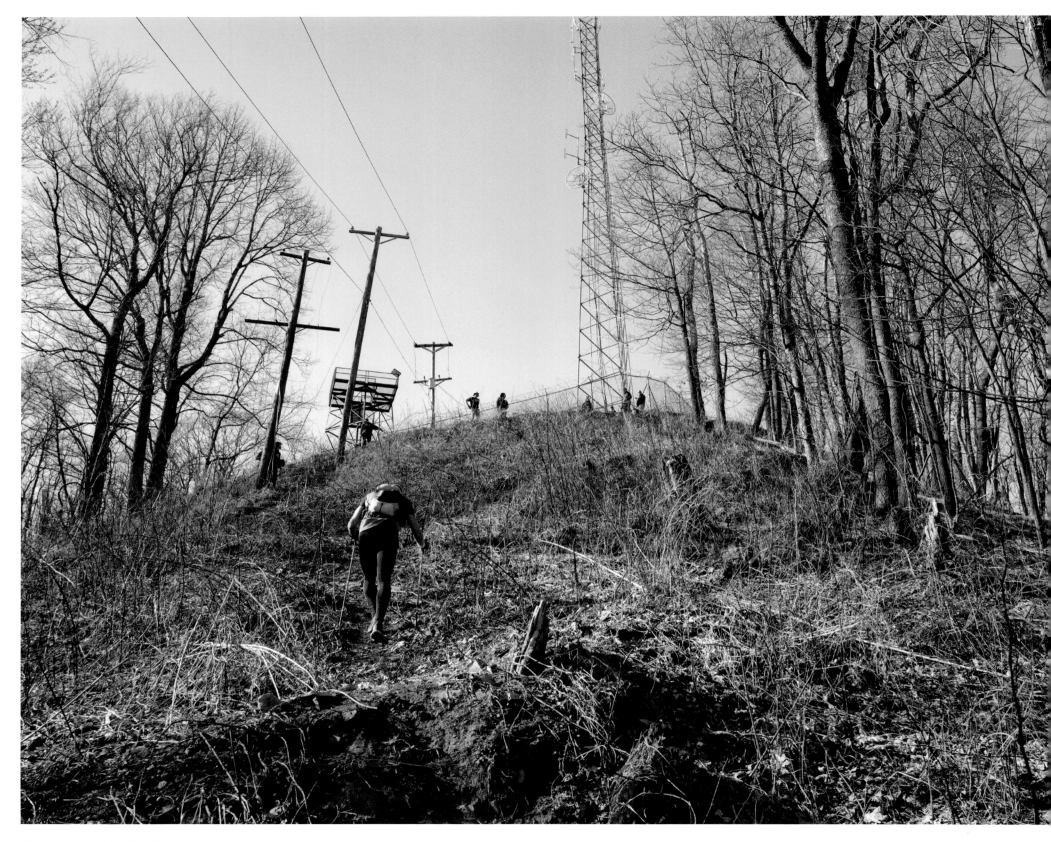

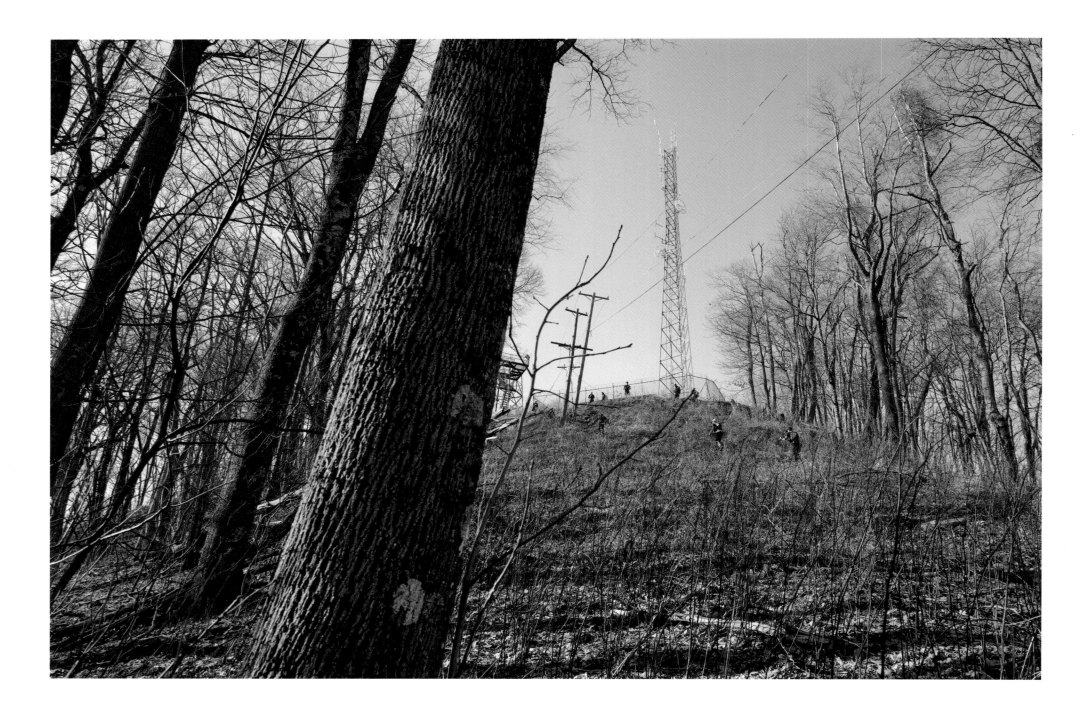

DO NOT BLOCK GATE

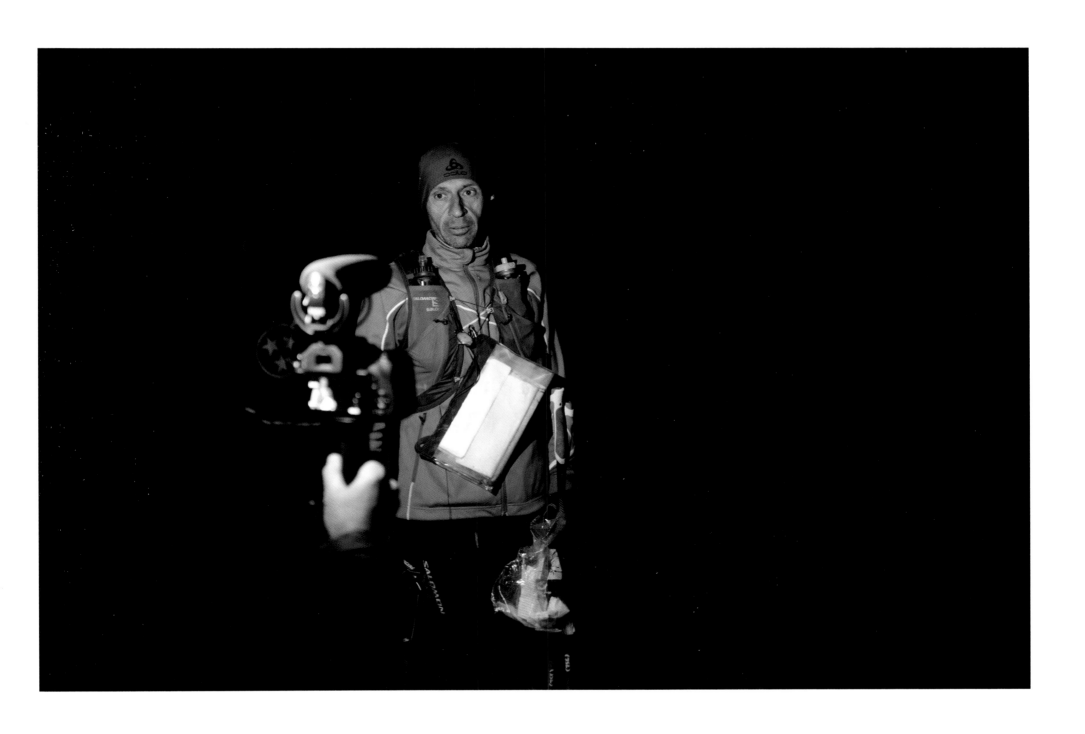

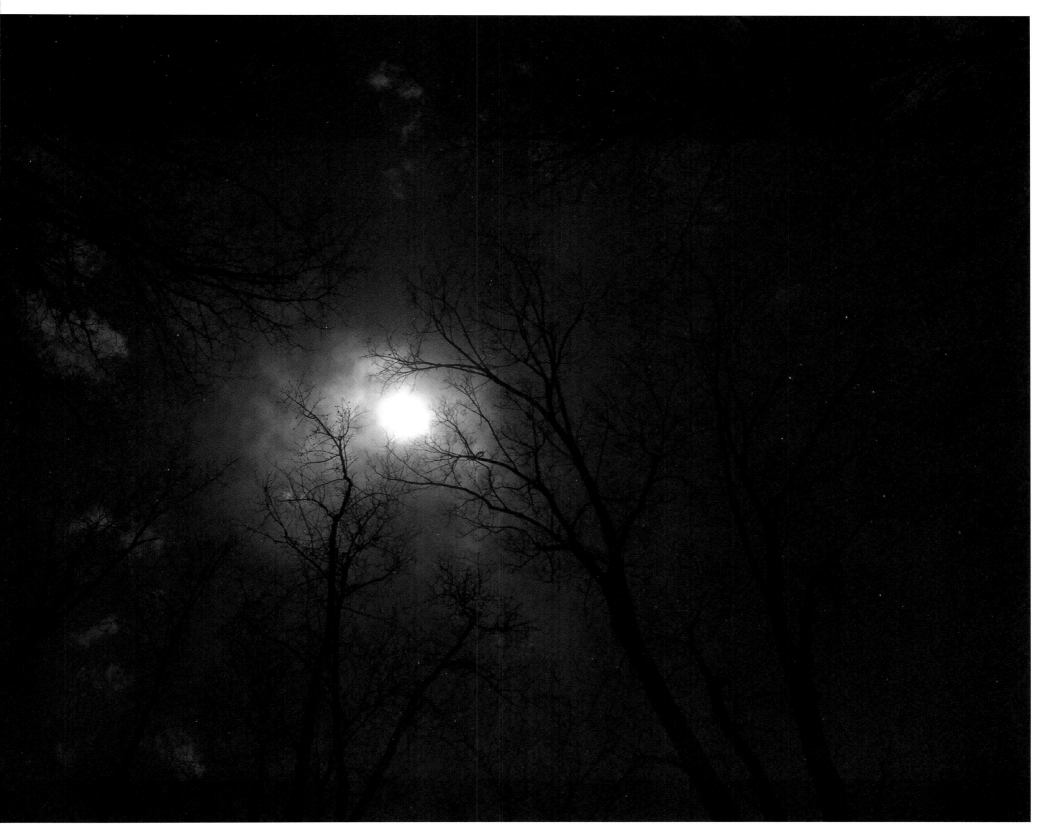

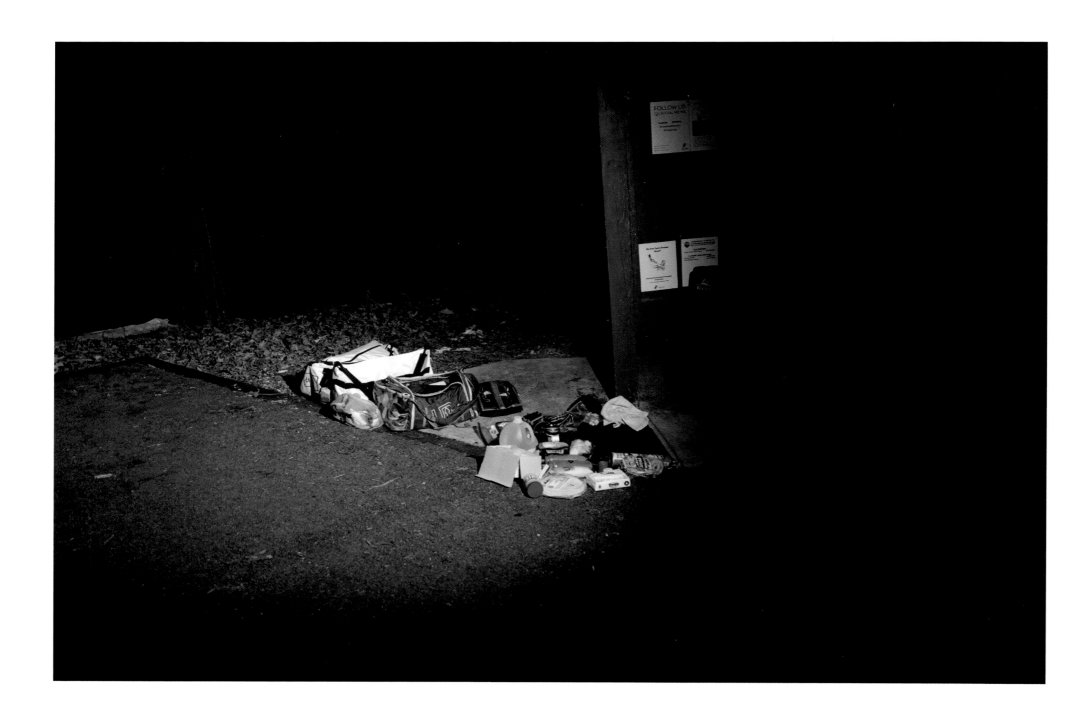

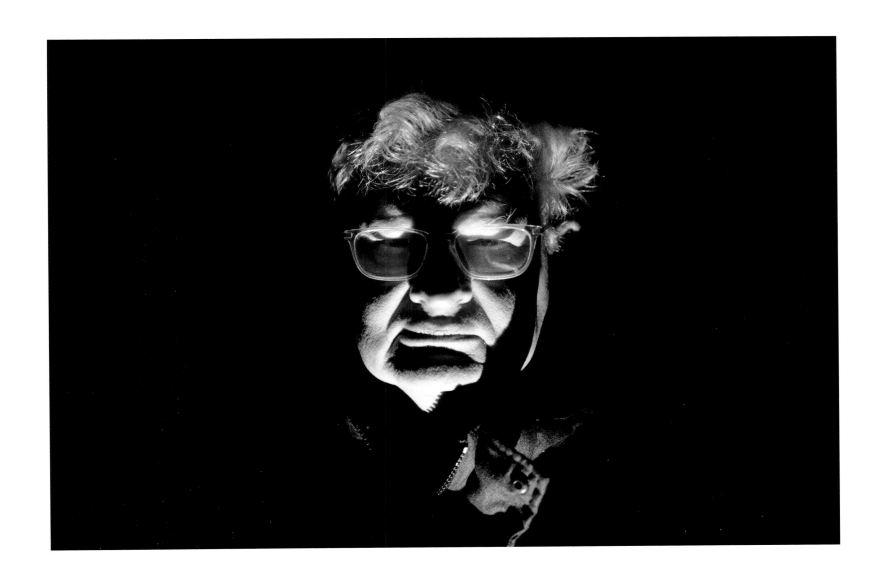

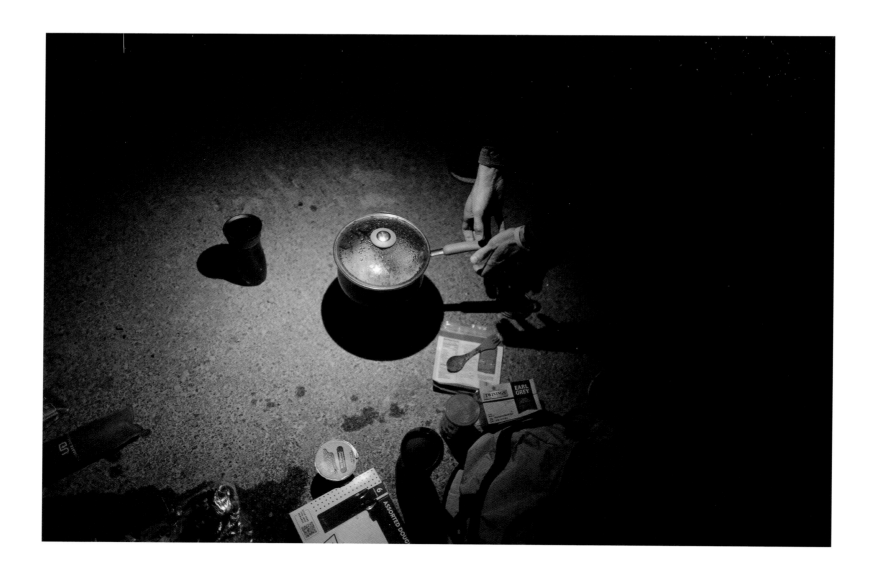

DO NOT BLOCK GATE

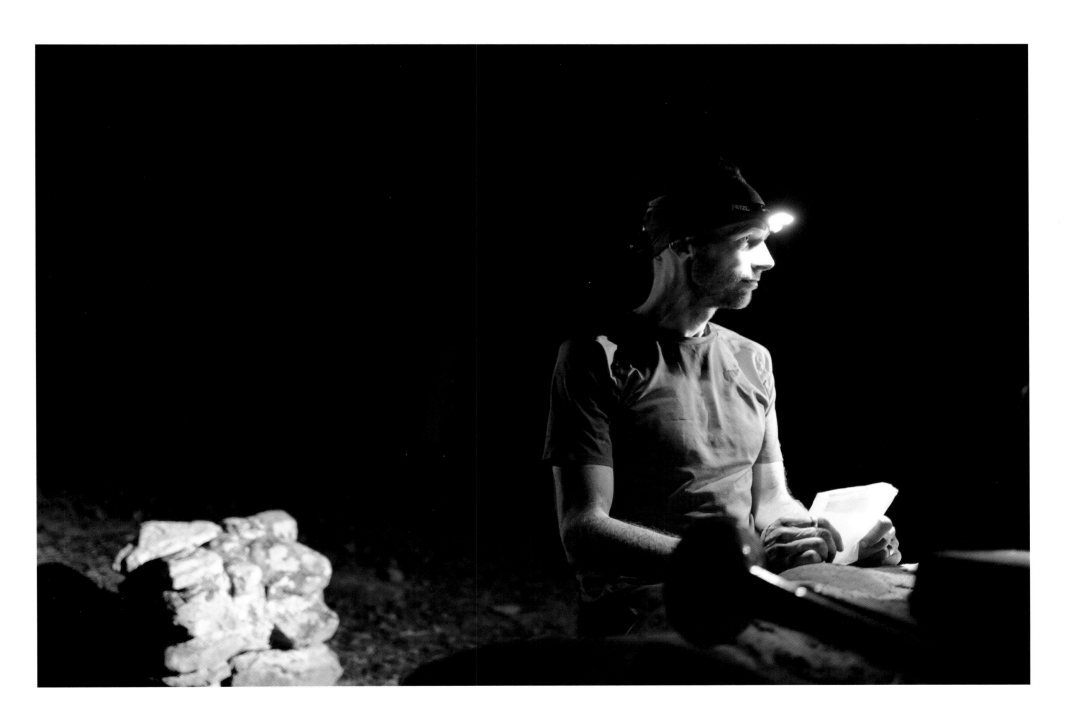

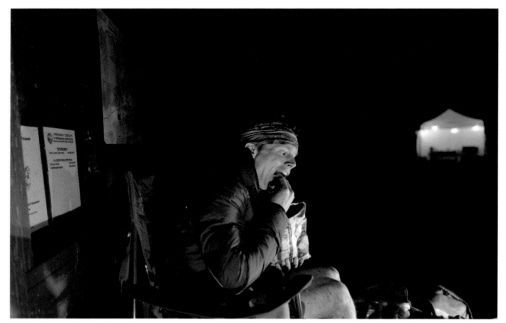

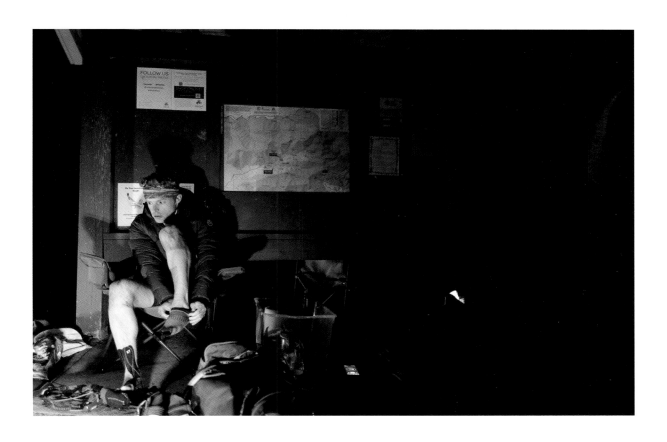

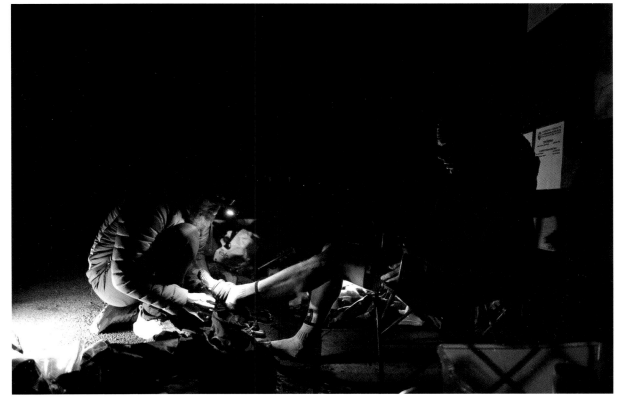

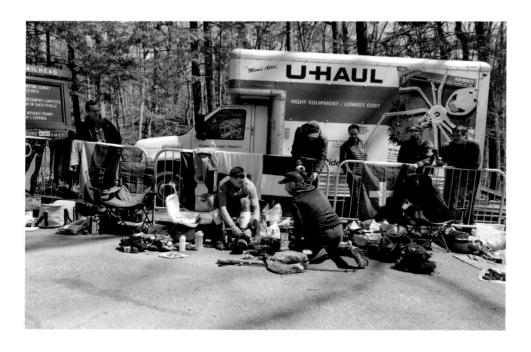
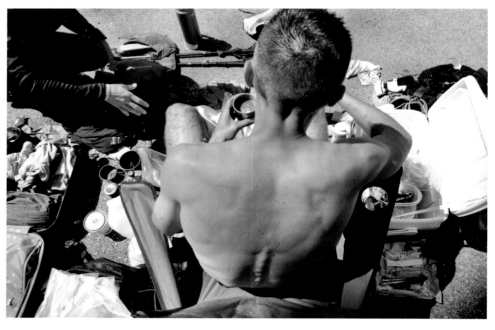
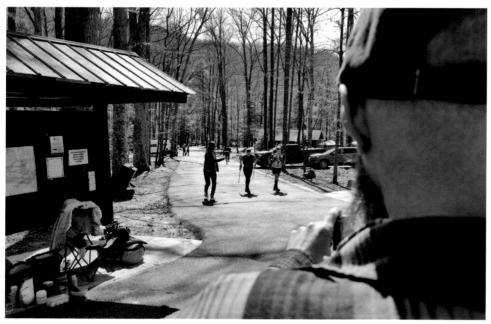
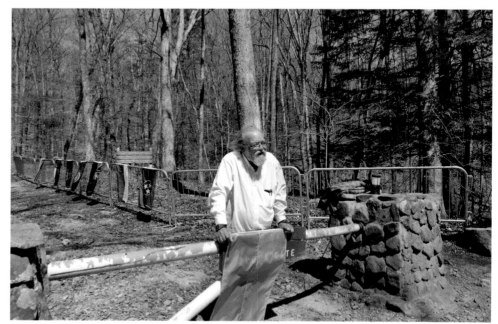

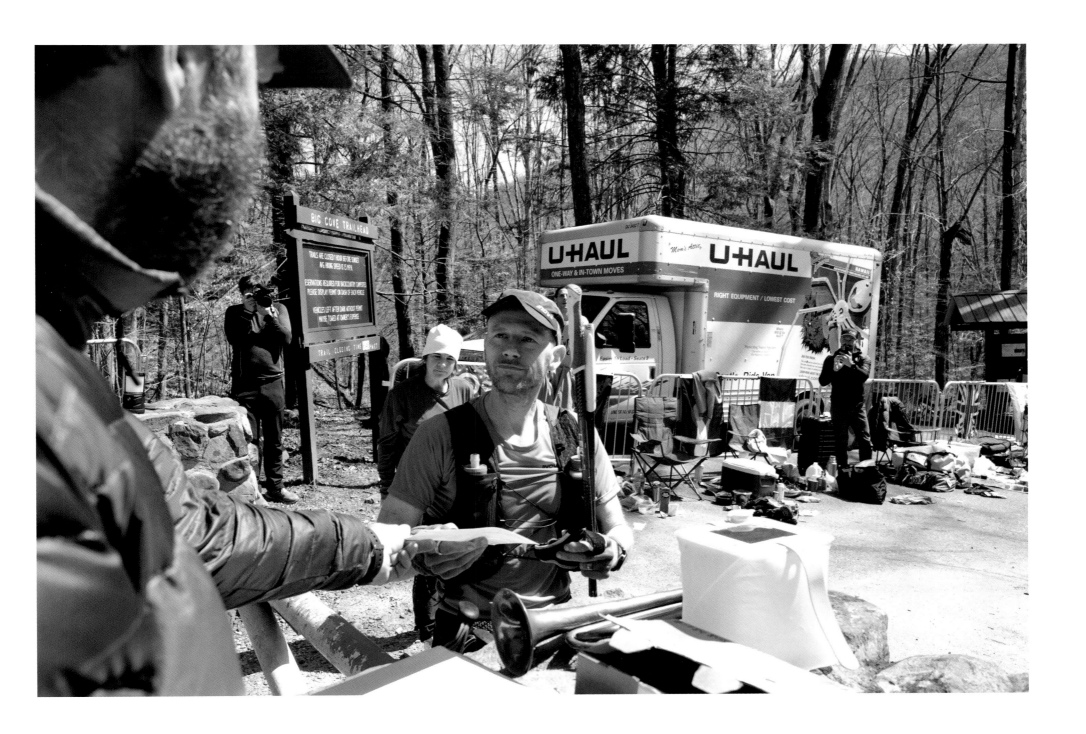

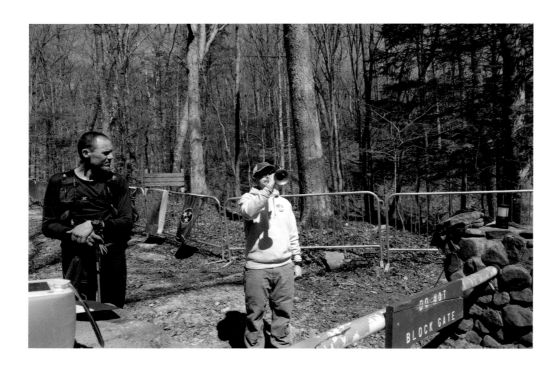

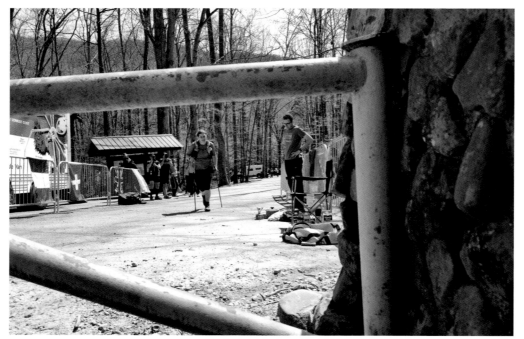

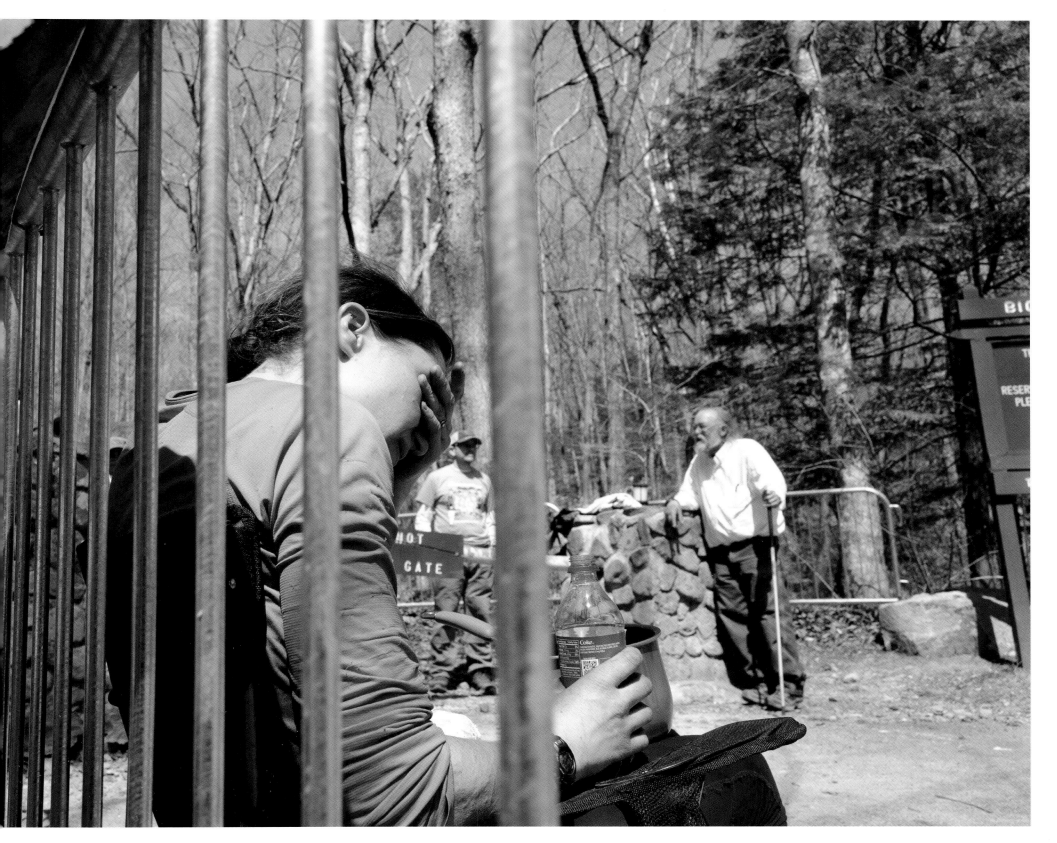

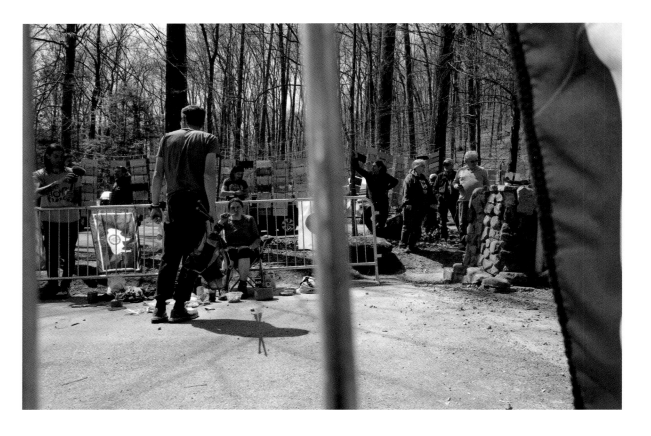

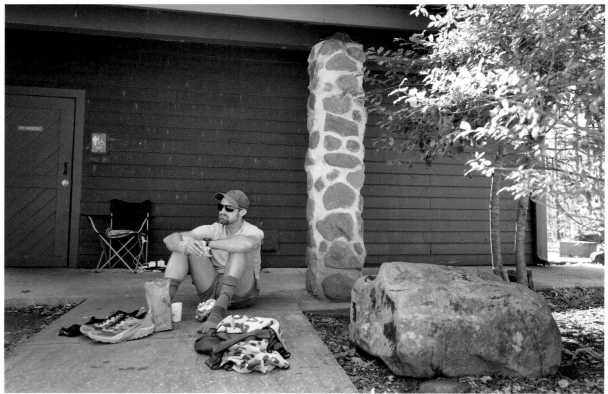

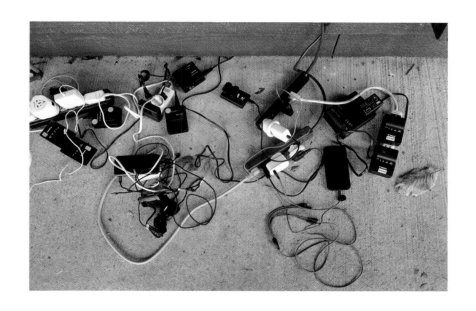

DO NOT BLOCK GATE

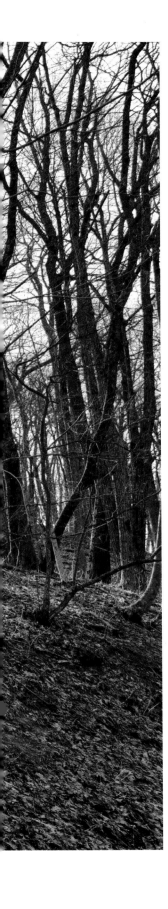

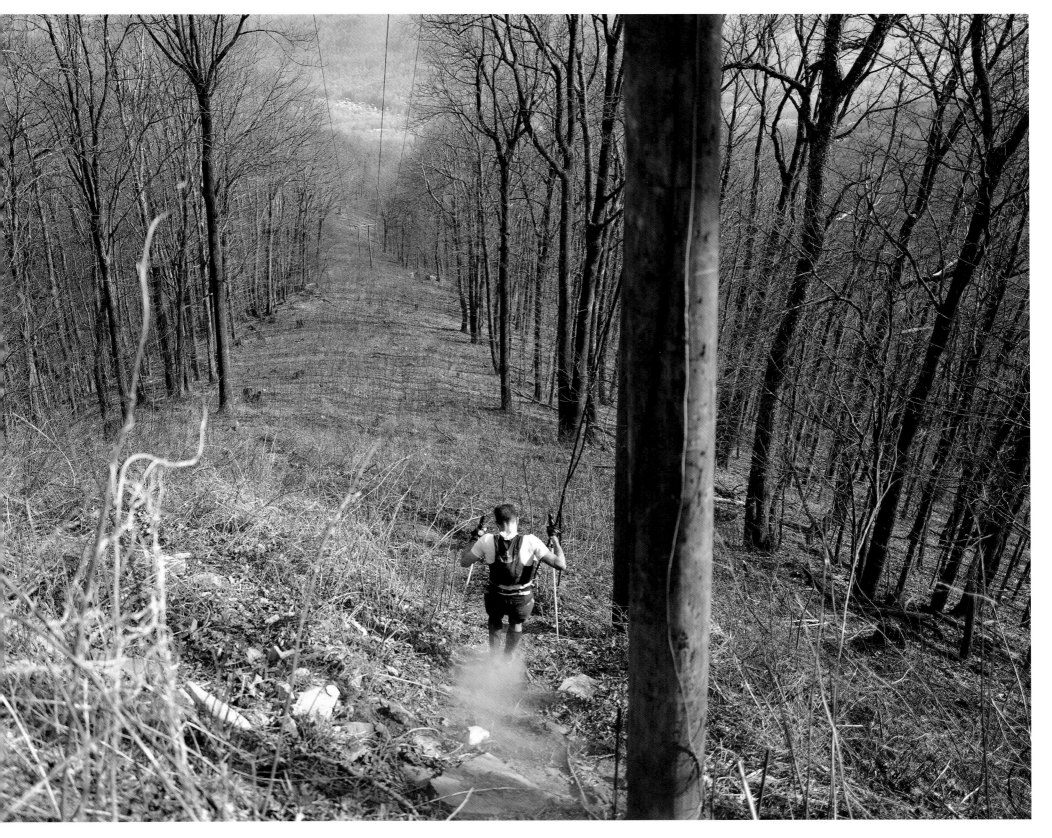

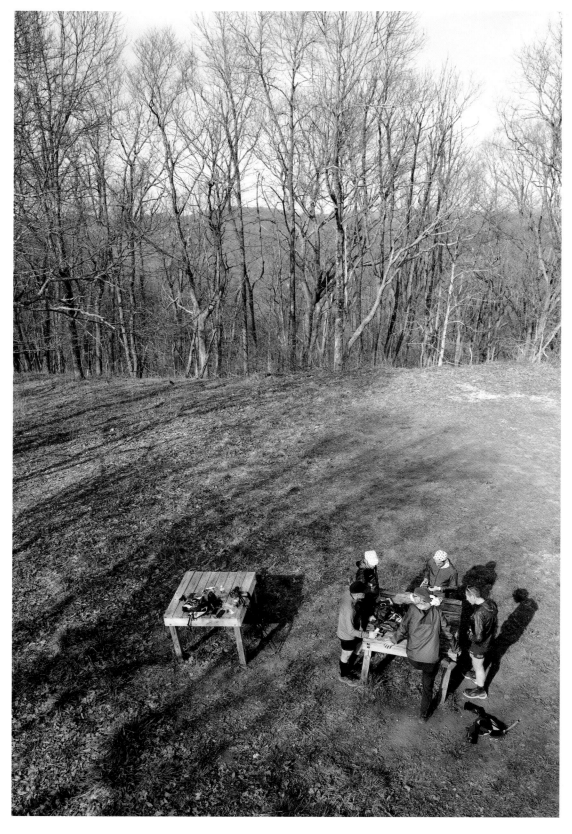
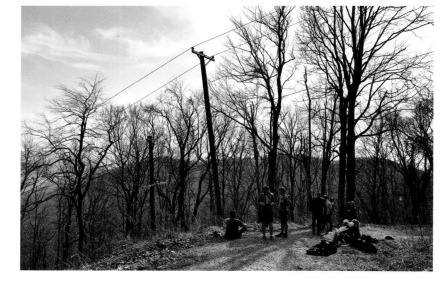

DO NOT BLOCK GATE

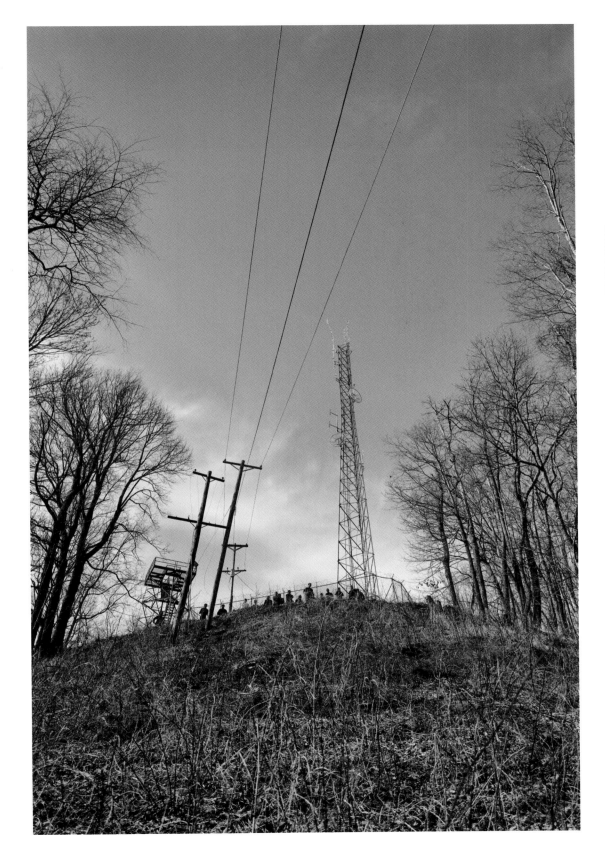

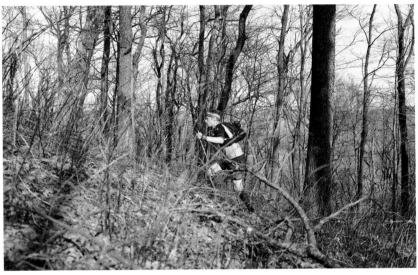

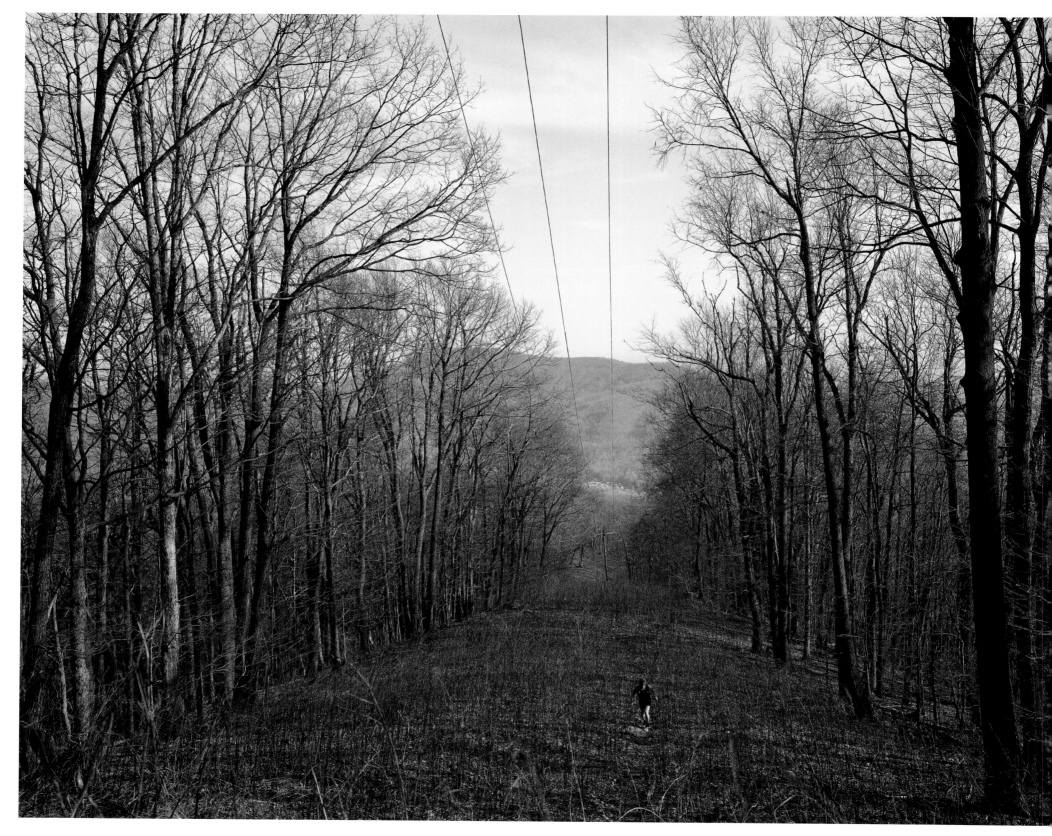

DO NOT BLOCK GATE

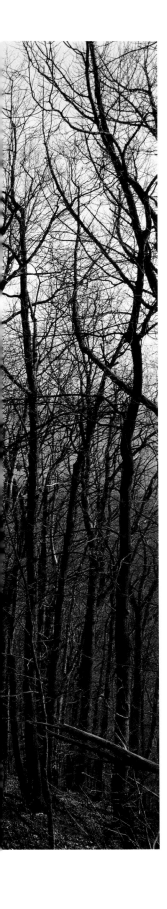

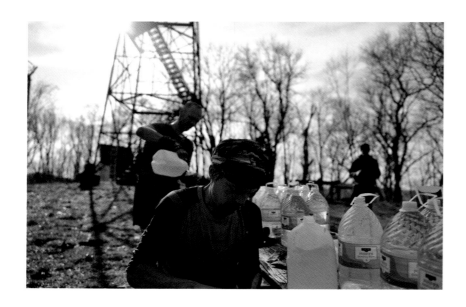

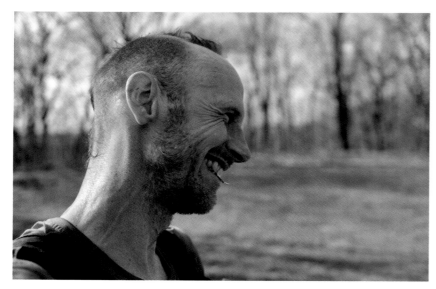

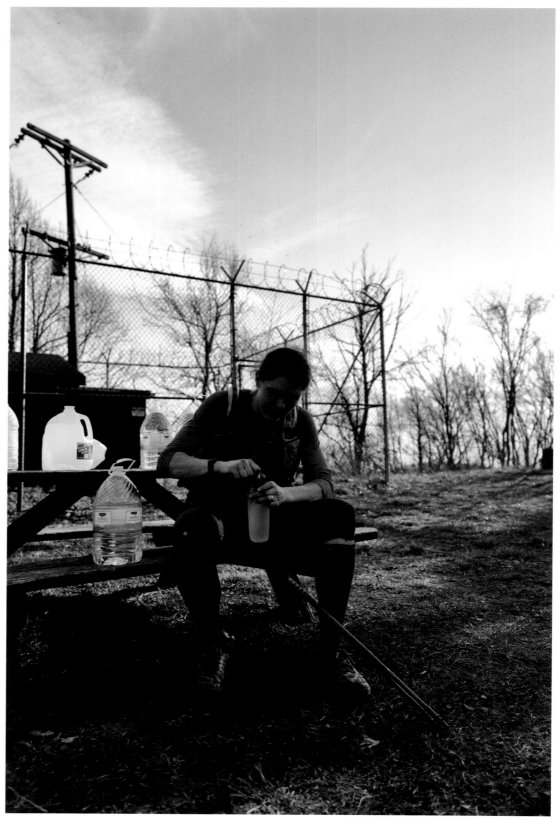

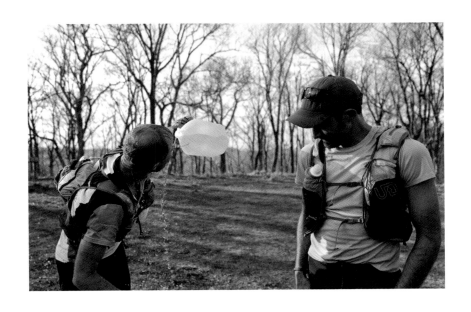

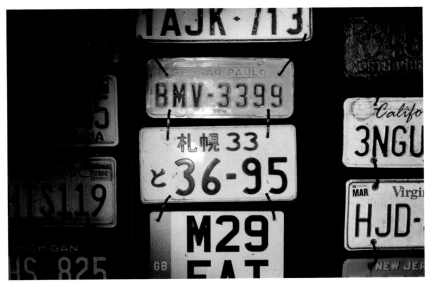

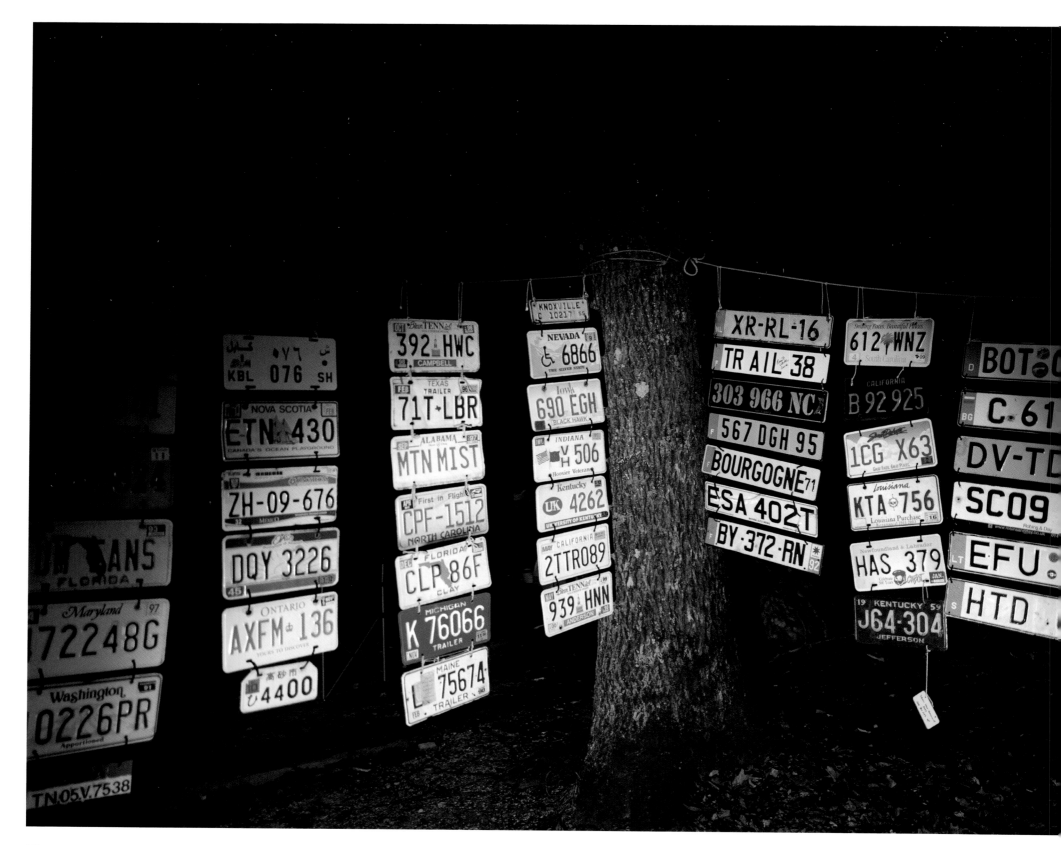

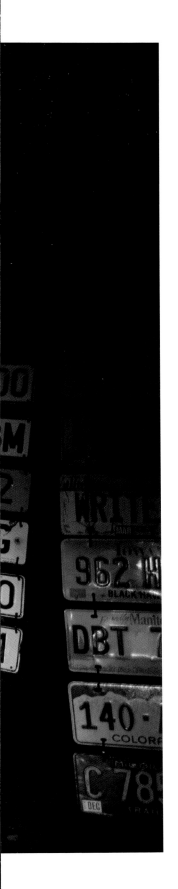

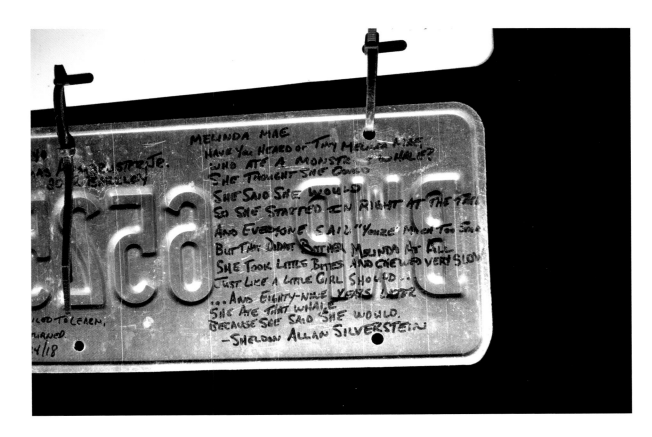

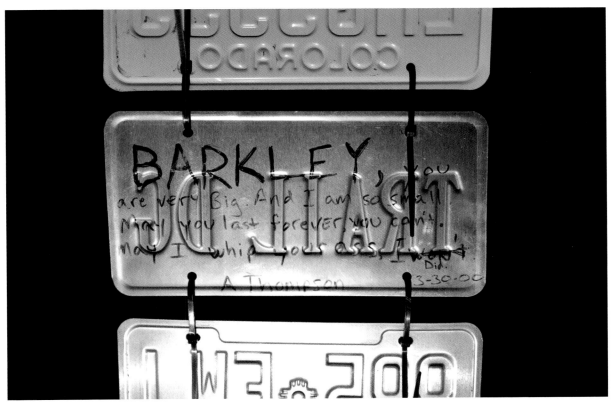

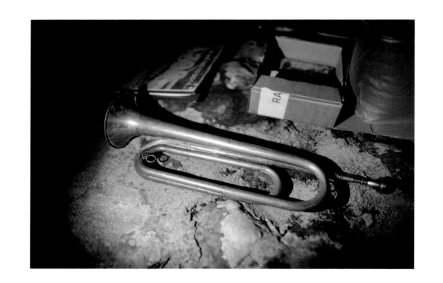

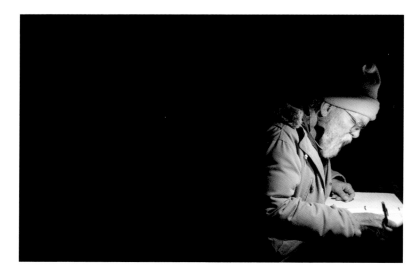

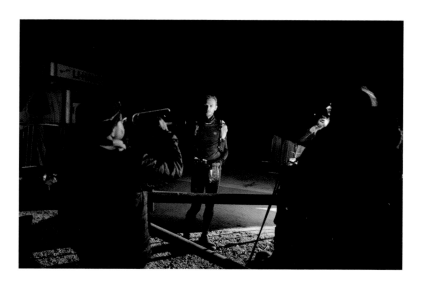

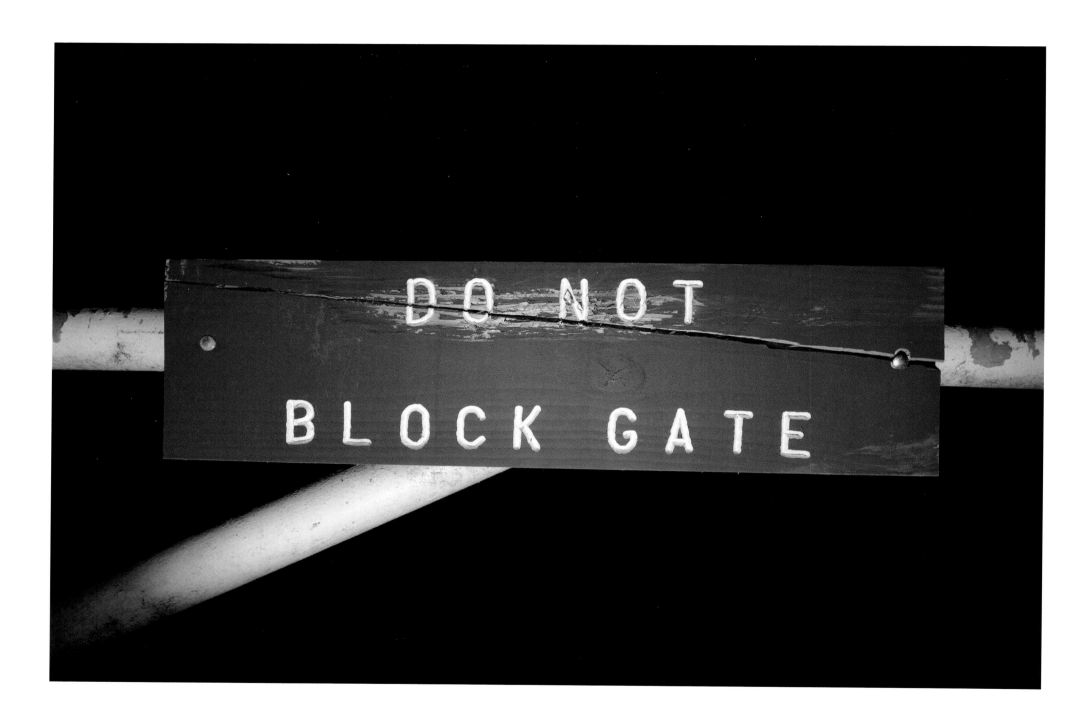

DO NOT BLOCK GATE

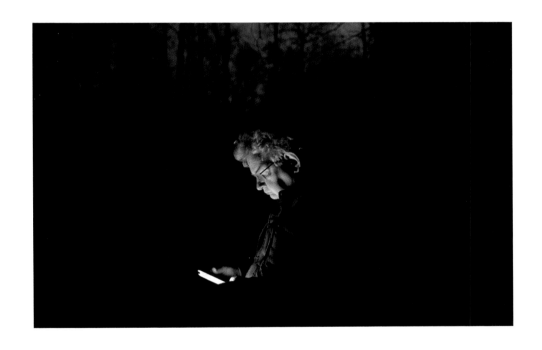

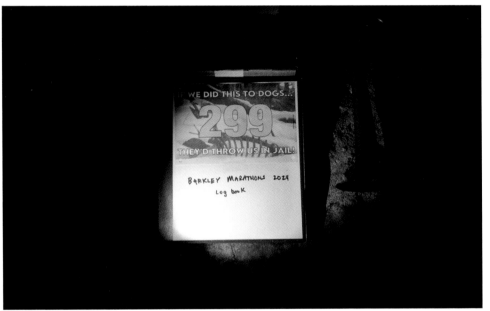

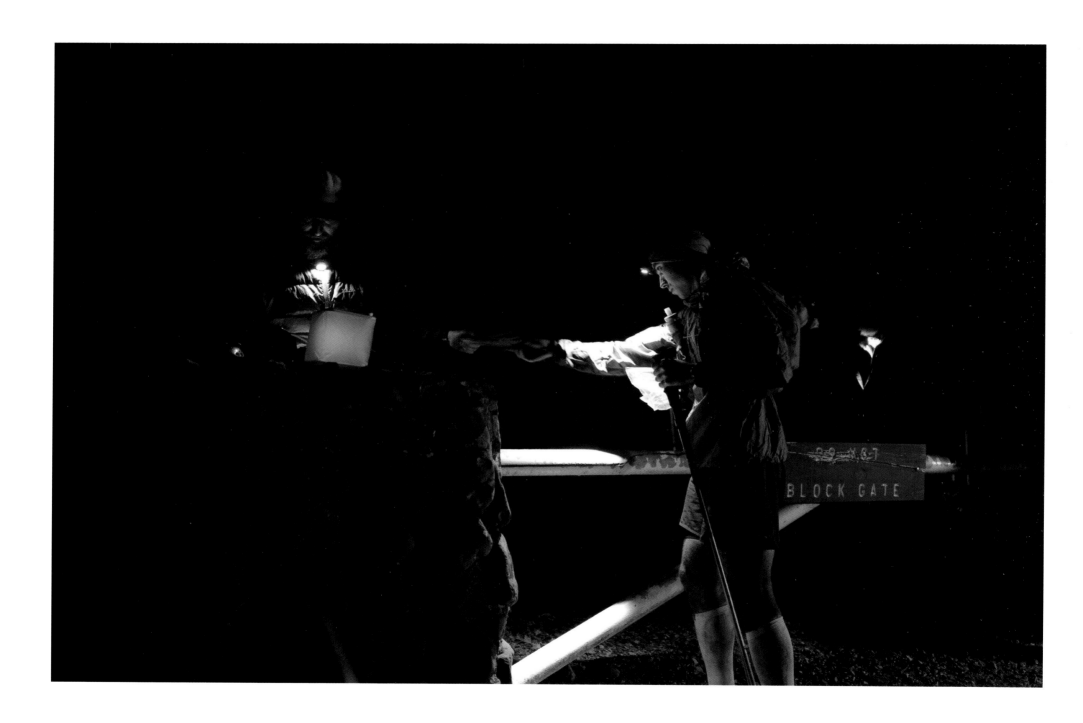

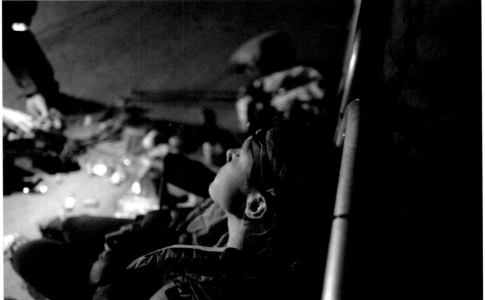

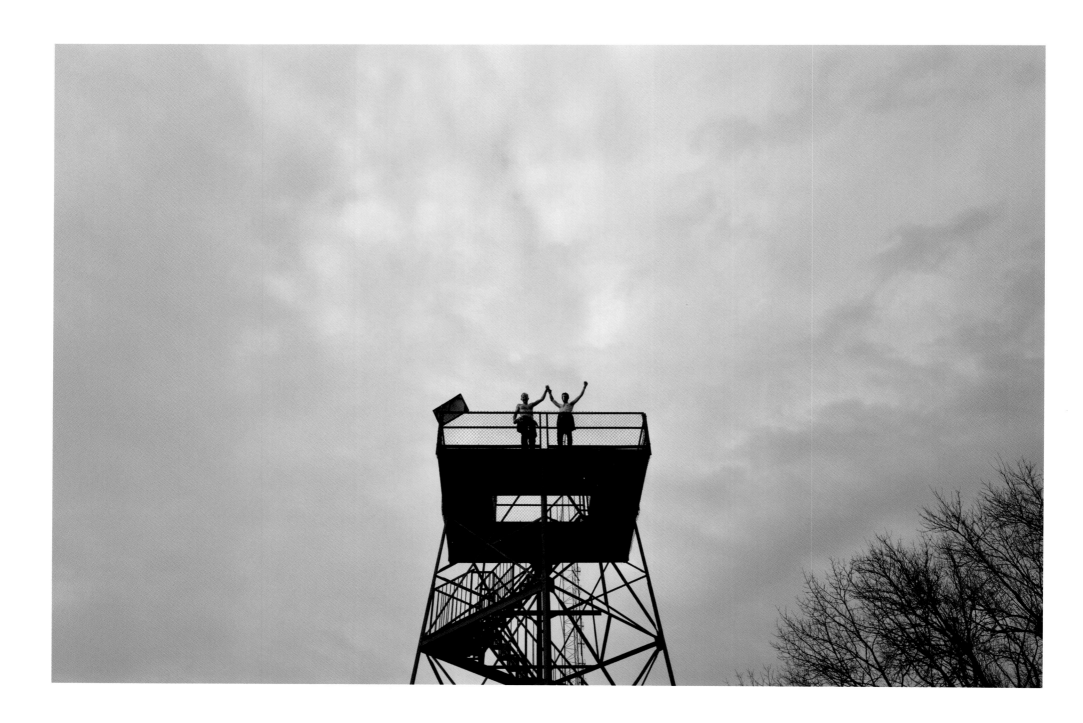

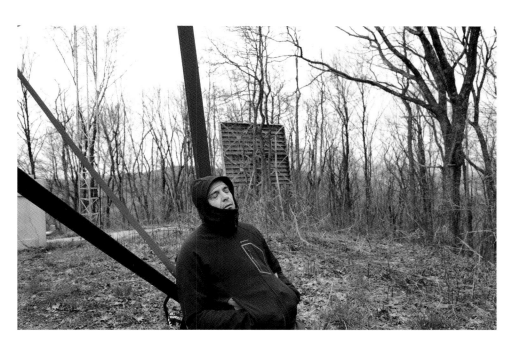

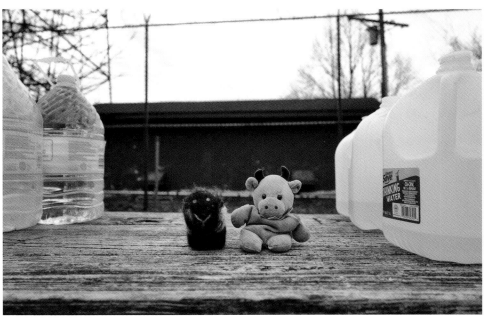

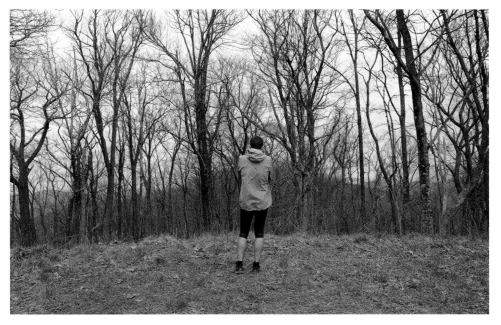

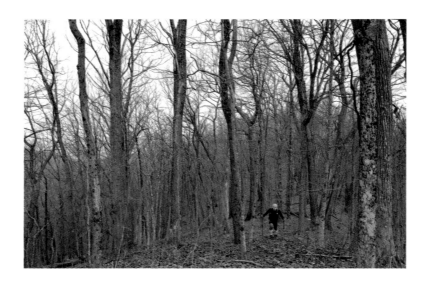

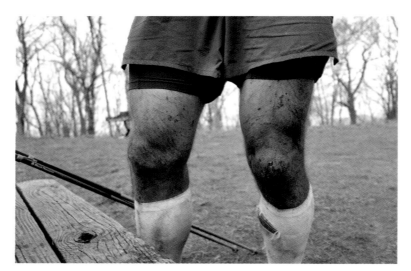

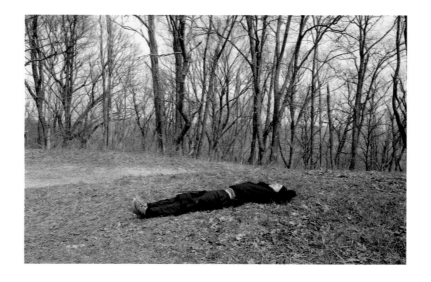

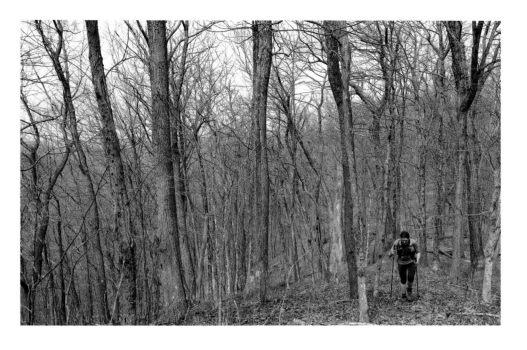
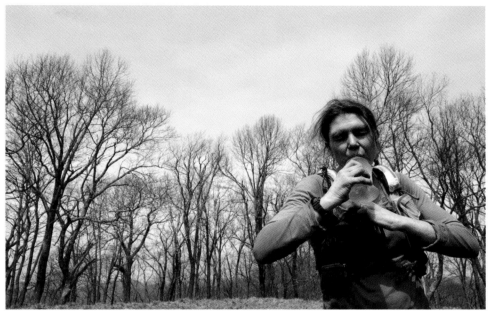
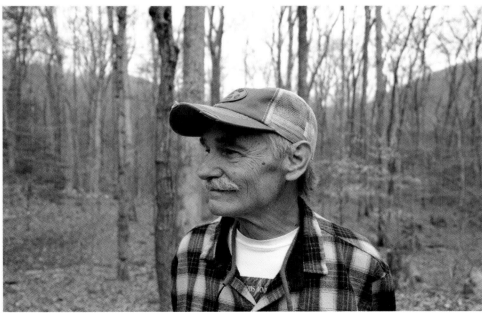

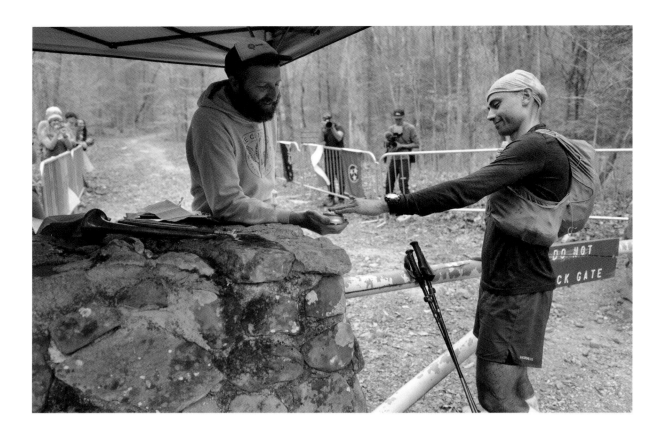

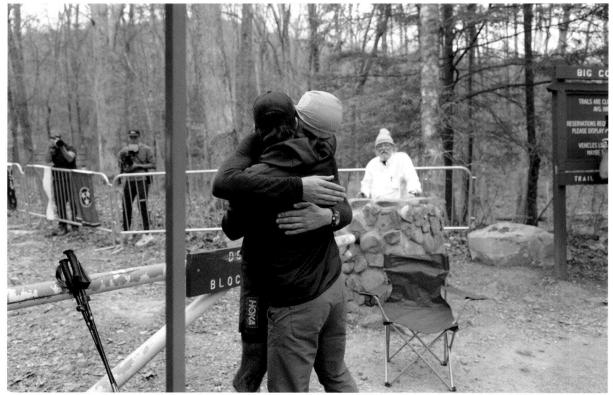

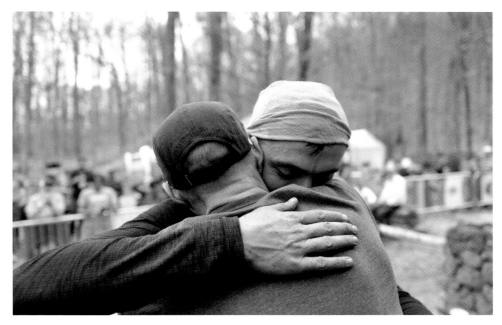

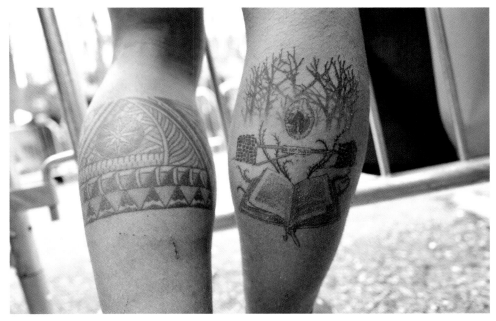

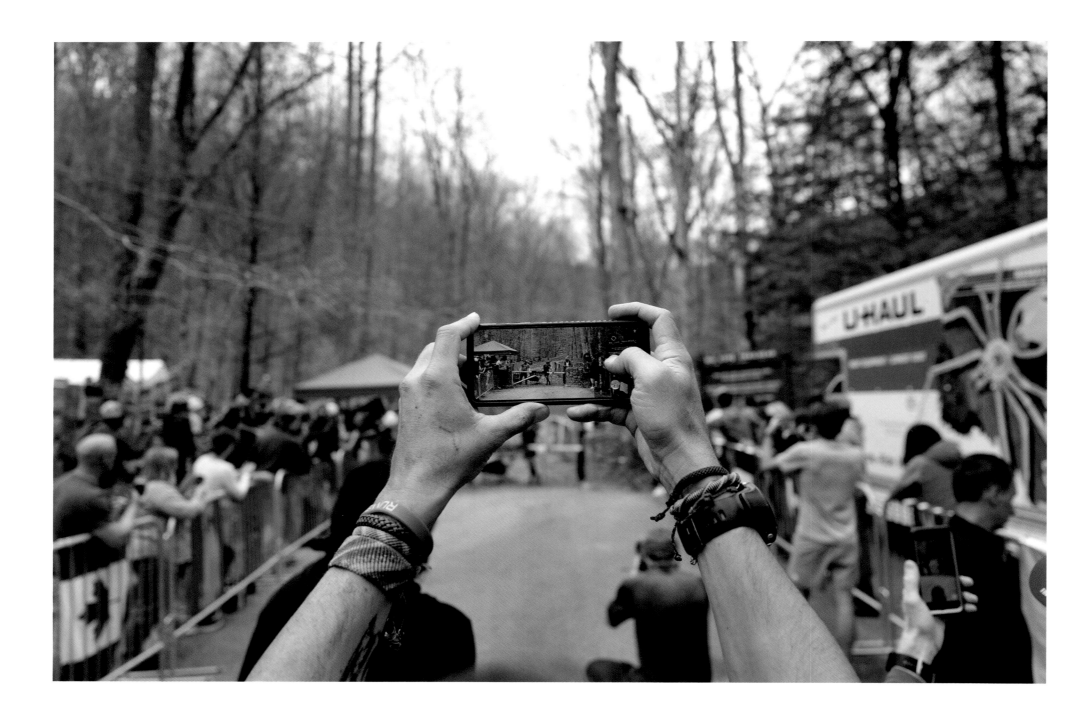

DO NOT BLOCK GATE

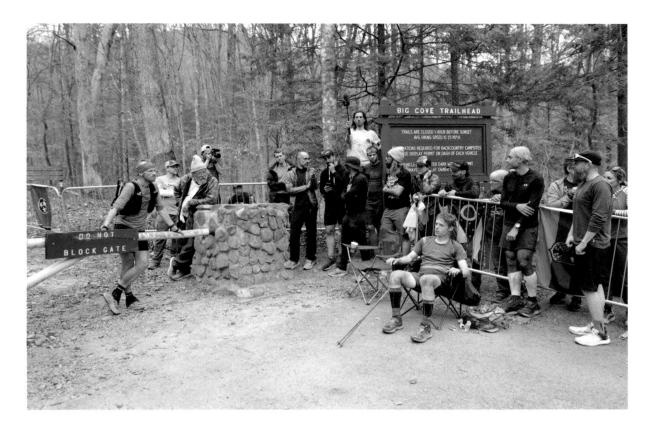

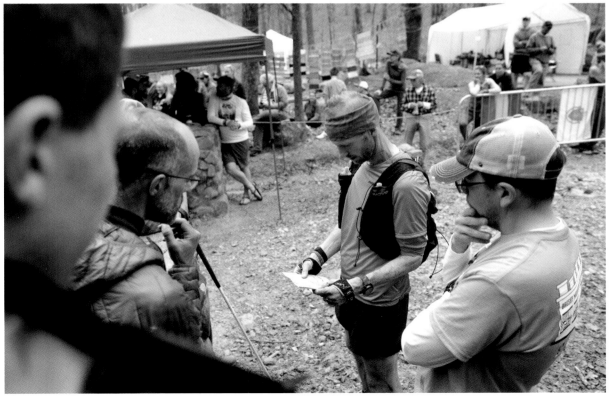

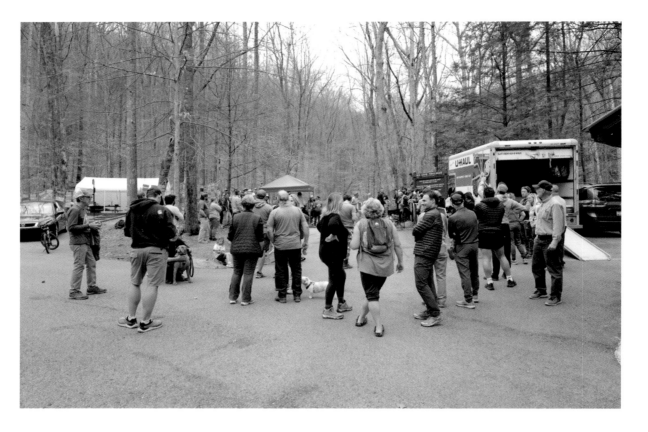

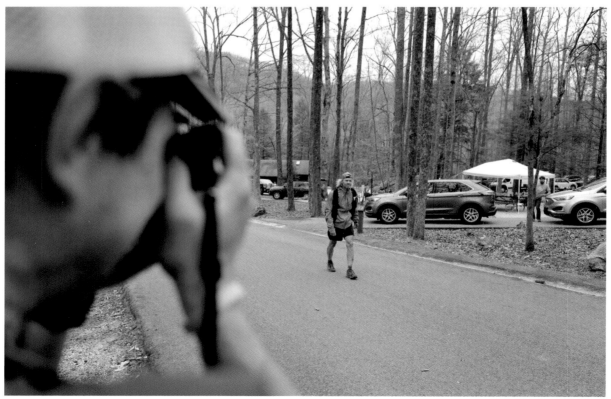

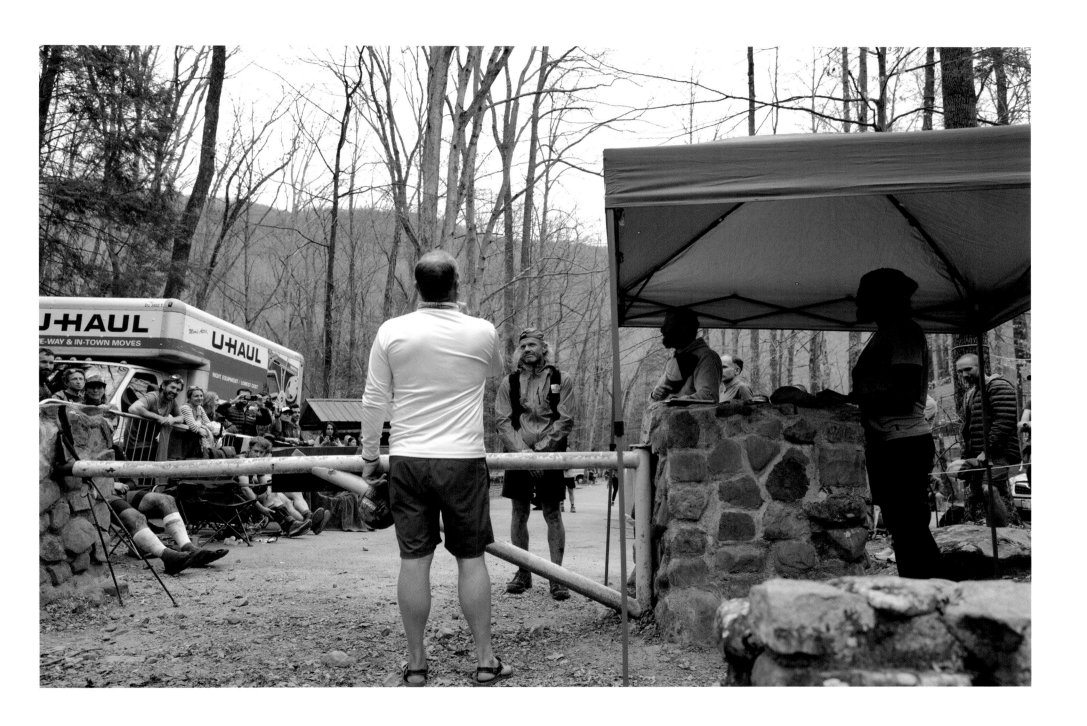

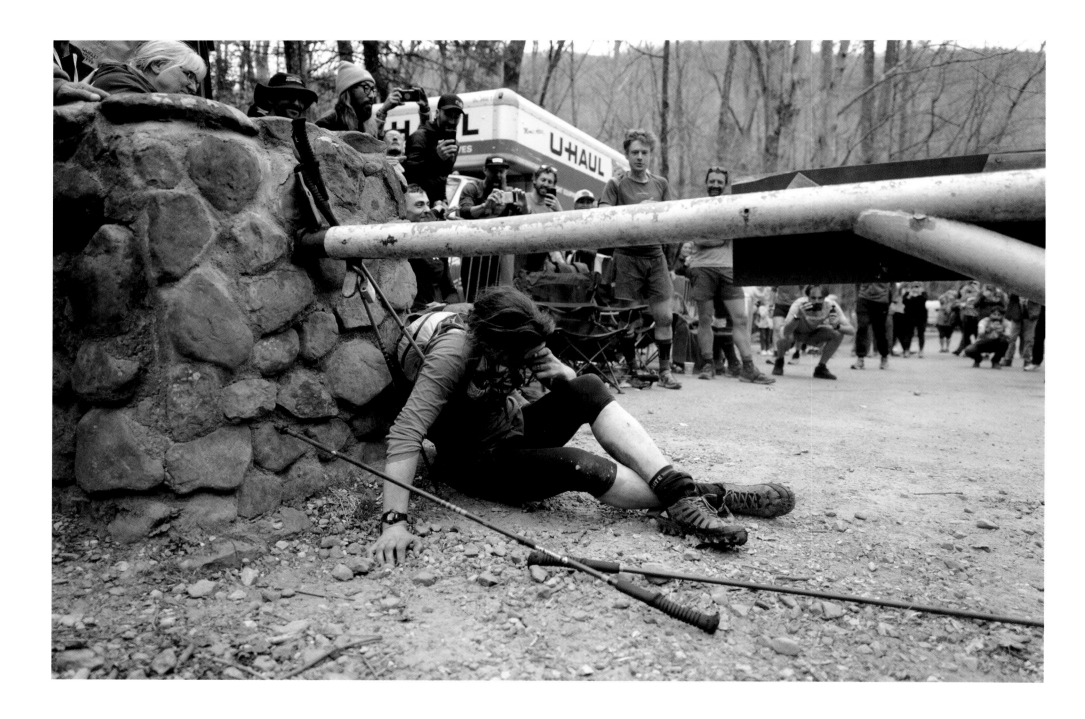

'I've never had to dig as deep as I did on that final sprint to the gate. I had nothing left to give, my legs and lungs were screaming at me to stop, the crowd on either side reduced to a blur of colour and noise. I ran straight into it, unable to control any sort of deceleration, my body flipping forwards before sliding to the ground. I can't really recall any sense of achievement at that moment, just an overwhelming feeling of relief at being able to breathe. I lay under that gate gasping for what felt like an age, completely spent, having given everything I had.'

Jasmin Paris

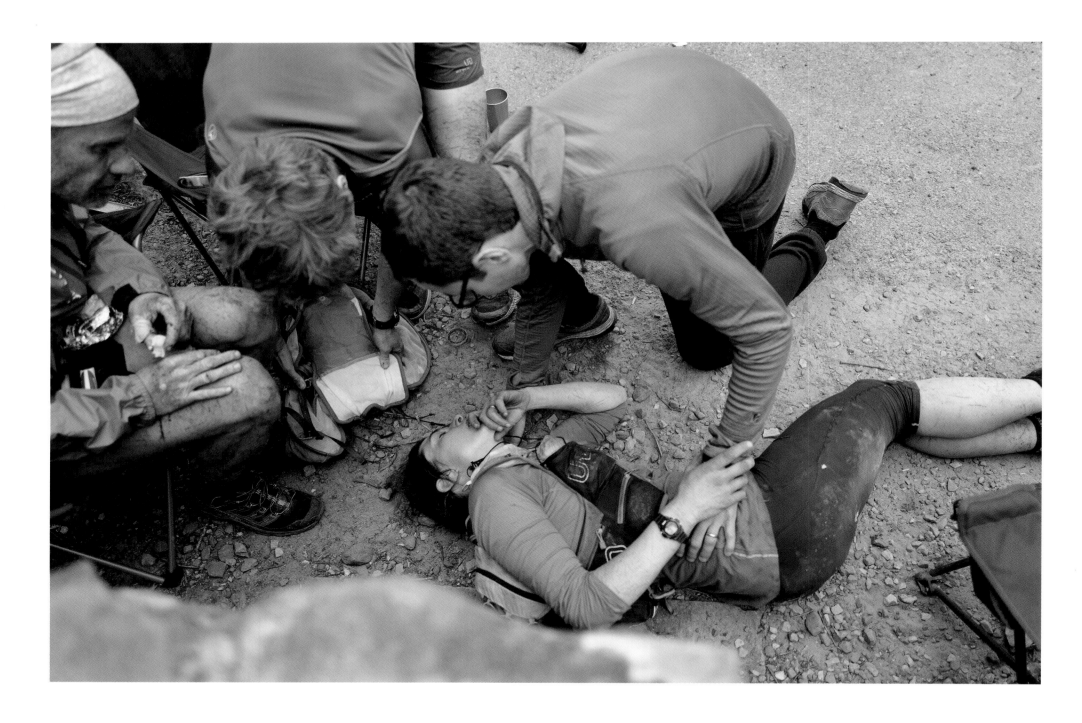

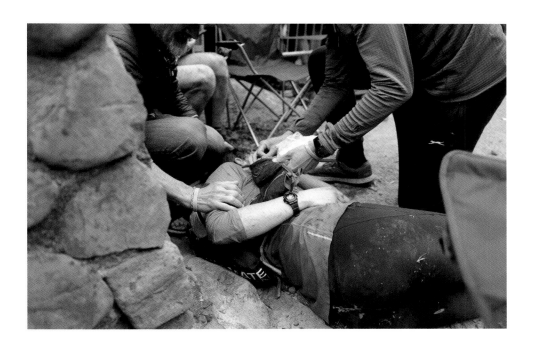

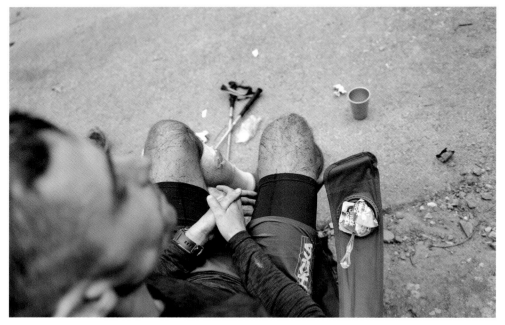

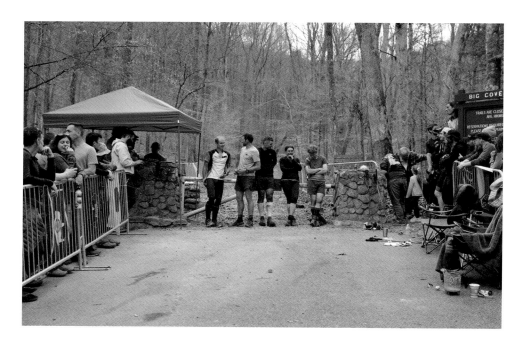

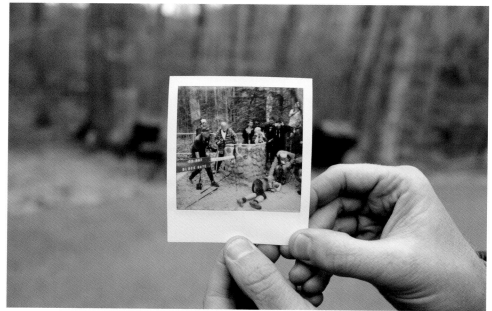

INDEX

124 (L–R) Fire tower meeting;

Crew/support waiting for the runners at the top of Rat Jaw.

125 (L–R) Crew/support waiting for the runners at the top of Rat Jaw;

John Kelly ascending Rat Jaw.

126–127 Damian Hall ascending Rat Jaw.

128 (L–R) John Kelly and Damian Hall at the fire tower;

Jasmin Paris at the fire tower;

Damian Hall.

129 (T–B) Greig Hamilton and Jared Campbell hydrating at the fire tower;

Barkley participants' number plates (past and present), Big Cove Campground.

130–131 Barkley participants' number plates (past and present), Big Cove Campground.

132 (T–B) The 'taps' bugle;

Lazarus Lake;

Tapping out.

133 Lazarus Lake.

134 The yellow gate, Big Cove Campground.

135 (L–R) Keith Dunn;

2024 Barkley Marathons logbook.

136 Ihor Verys.

137 (L–R) Damian Hall;

Jasmin Paris sleeping after loop four.

138 Harvey Lewis and Ronan Pierre up the fire tower.

139 (L–R) Barkley media power nap, fire tower;

Jasmin Paris's mascots, fire tower;

Konrad awaiting Jasmin at the fire tower.

140 (T–B) Ihor Verys approaching the fire tower;

Ihor Verys at the fire tower;

Harvey Lewis.

141 (L–R) Jasmin Paris approaching the fire tower;

Jasmin Paris hydrating at the fire tower;

Frozen Ed;

Big Cove Campground.

142 (T–B) Ihor Verys finishing the 2024 Barkley Marathons – 'That was easy';

Ihor Verys and his crew.

143 (L–R) Ihor Verys and his crew;

Ihor Verys and Gary Robbins;

Aurélien Sanchez's tattoo.

144 John Kelly finishing the 2024 Barkley Marathons, becoming a three-time finisher.

145 (T–B) Damian Hall returning before being tapped out on loop five;

Damian Hall.

146 (T–B) Big Cove Campground;

Taking 'quitter's road' before being tapped out on loop five.

147 Tapping out.

148 The moment Jasmin Paris become the first ever female finisher at the Barkley Marathons.

150–151 Jasmin Paris and Konrad.

152 (T–B) Carl Laniak;

Ihor Verys.

153 (T–B) Jasmin Paris;

2024 Barkley Marathons finishers – Ihor Verys, John Kelly, Jared Campbell, Greig Hamilton and Jasmin Paris.

154 (T–B) 2024 Barkley Marathons finishers – Ihor Verys, John Kelly, Jared Campbell, Greig Hamilton and Jasmin Paris;

Jasmin Paris Polaroid.

155 Frozen Head State Park.

A NOTE OF THANKS

The author and publisher would like to thank the following people for their support of the *Do Not Block Gate* project:

Bill Aiken
Joe Allen
Stephen Allport
Colin J. Anderson
Keith Anderson
Joe Anderton
Steve Andrews
Stuart Arnold
Robert Asher
David Axenborg
Adam Badrawy
Allie Bailey
Kim and Ella Baxter
Lee Beall
Gillian Bell
Paul Billing
Mark Blaszczyszyn
Kevin Bowen
Sarah Bradley
Bram
Sebastian Briggs and family
Rebecca Cam
Camilla (from David)
Maarten Caminada
Richy Campbell
Ethan Carlson
Paula M. Carlson
Greg Christiansen
Claire Christie
Rebecca Cockman Goodford
Elly Cope
Brian Cullen
Robert Cullen
Katie Curwen
Dagautier
Damon
Darren
Richard Darroch
Gareth Davies
Robert DePietro
Lynne Dixon

Greg Duce
Keith Dunn
Lorenzo Dutto
Mary Ann Emanuel
Douglas Emslie
Andrew Ernill
Abhijith Eswarappa
Jith Eswarappa
Philipp von Euw
Darren Evans
Peter Van Eylen
Sam Floyd
Edward Fogden
Sam George
Samantha Gibson
Sally Gilson
Joanne Glister
Bruce Gray
Neil Green
Lisa A. Greenhalgh
Tom Hackett
Brooke Harding
Clint Harper
David Harrison
Chris Heath
Olivia Hetreed
Ian Hickman
Will Hicks
Anthony Hlynka
Liz Holdsworth
Matt Holtwick
Lyndsey Hookway
Robert Hornshaw
Tom Hoyle
Karl Huntbach
Amy Iredale-Mitchell
Levet Jacques
Jim
Todd Johns
William Johnson
Jonathan

Charis Jones
Paul Jones
Brono Kandrik
Kate (RunUltra)
Alistair Kerr
Nicola Kidd
Kim
Heleen Koudijs
Howard Lancashire
Henry Lazarowicz
Jean-Paul Lekkerkerker
Jon Light
Martin Little
Charlotte and Scott Logie
Elaine Maag
Philip McCarron
Alexandra McClellan
Gillian McGale
Ann McKenzie-Ayling
Øystein Stokvik Malme
Matt and Karen, the Timing Monkeys
Elie Mélois
Ben and Mel Middleton
Freddie Miller
Louie Miller
Lynda Moralee
Frank O'Leary
Pablo Segura
Carter Parks
Martin Pearn
Jo Pedley
Sam Phelps
Stephanie Plummer
Christian Pohl
Camilla Raynham
Dennis Rieke
Emma Roe
Cynthia Ruddock

Ben Ryan
Martin Sanderson
Pylin Jane Sanguanpiyapand
Michele Sarzana
Marton Sasvari
Carolyn Schuster-Woldan
Heather Self
Kevin Sheffield
Andrew Shiel-Redfern
Sir Twonkalot
Phil Smith
Nicola Sommers
Sophie and Nick
Jasper Spaans
Giacomo Squintani
Victoria Staines
Anthony Stevens
Jason M. Stevens
Louise Stewart
Linda P. Strawn
Techlover
Haydn Thompson
Rachel and Stuart Thomson
Simon Thorne
Giles Thurston
Annie Toole
Fiona Tweedie
Derek Tyers
Duncan Walling
Derrick Wess
Isaiah Whisner
Benjamin Whittam
Carol Wilson
Doug Wilson
Siona Worrall
Michelle Young

Two per cent of profits from this project will be donated to **The Green Runners**, a running community making changes for a fitter planet. *www.thegreenrunners.com*

DO NOT BLOCK GATE
THE 2024 BARKLEY MARATHONS
DAVID MILLER

First published in 2024 by Vertebrate Publishing.

 Vertebrate Publishing
Omega Court, 352 Cemetery Road, Sheffield, S11 8FT, United Kingdom.
www.adventurebooks.com

A CIP catalogue record for this book is available from the British Library.

Paperback ISBN: 978-1-83981-244-6

Edited by Helen Parry; design and production by Jane Beagley,
www.adventurebooks.com

Vertebrate Publishing is committed to printing on paper from sustainable sources.

Printed and bound in Slovenia by Latitude Press.